MASTER CLASS PHOTOGRAPHY SERIES

CREATIVE STILL LIFE PHOTOGRAPHY

Bruce Pendleton is a studio photographer with nearly 25 years of professional experience. Particularly well-known for his annual report and advertising photography, his clients include IBM, Ford, Howard Johnson's, Nestle, Minolta, Pierre Cardin, Pepsi Cola, Heublein, and Sony. His work has also appeared in *Look* and on many covers of *Stereo Review* magazine. Mr. Pendleton has taken the photographs for six illustrated books, and also produces industrial films. He is a member of the American Society of Magazine Photographers.

MASTER CLASS PHOTOGRAPHY SERIES

CREATIVE STILL LIFE PHOTOGRAPHY

Bruce Pendleton

A SPECTRUM BOOK

PRENTICE-HALL, INC.
Englewood Cliffs, New Jersey 07632

This book is for my eleven-year-old daughter Paige,
who has done what I have never done:
won a photo contest.

A Quarto Book
Text copyright © 1982 by Quarto Marketing Ltd.
Photographs copyright © 1982 by Bruce Pendleton
All rights reserved. No part of this publication may be reproduced,
stored in a retrieval system, or transmitted, in any form or by any
means, electronic, mechanical, photocopying, recording or otherwise,
without the prior permission of Quarto Marketing Ltd.

Project Editor: Sheila Rosenzweig
Production Editor: Gene Santoro
Design Assistant: Effie M. Serlis
Produced and prepared by **Quarto Marketing Ltd.**
32 Kingly Court, London W1, England
Typeset by BPE Graphics, Inc.
Printed in Hong Kong

ISBN 013-191247-X hardcover; ISBN 013-191239-9 papercover.
This Spectrum Book is available to businesses and organizations
at a special discount when ordered in large quantities.
For information, contact Prentice-Hall, Inc.,
General Book Marketing, Special Sales Division,
Englewood Cliffs, N.J. 07632.
A Spectrum Book
10 9 8 7 6 5 4 3 2 1

ISBN 0-13-191247-X
ISBN 0-13-191239-9 {PBK.}

V.S.W.
Gift of publisher
9 May 1983

Library of Congress Cataloging in Publication Data
Pendleton, Bruce.
 Creative still-life photography.
 (The Master class photography series)
 Bibliography: p.
 Includes index.
 1. Still-life photography.
 I. Title. II. Series.
 TR656.5.P46 1982 778.9'35 82-10210

Contents

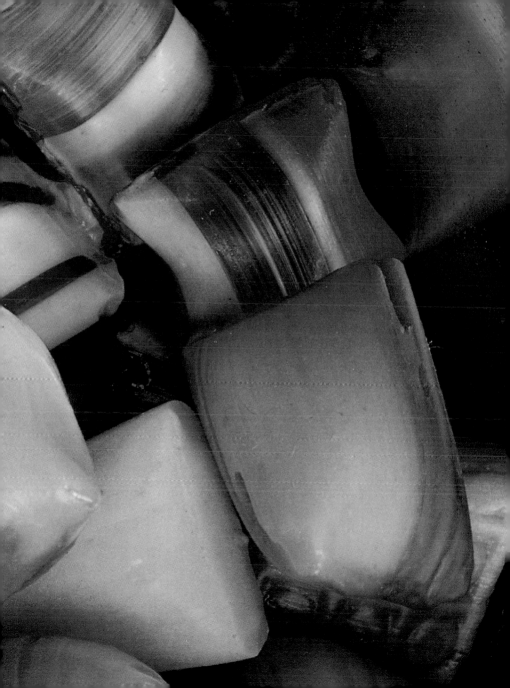

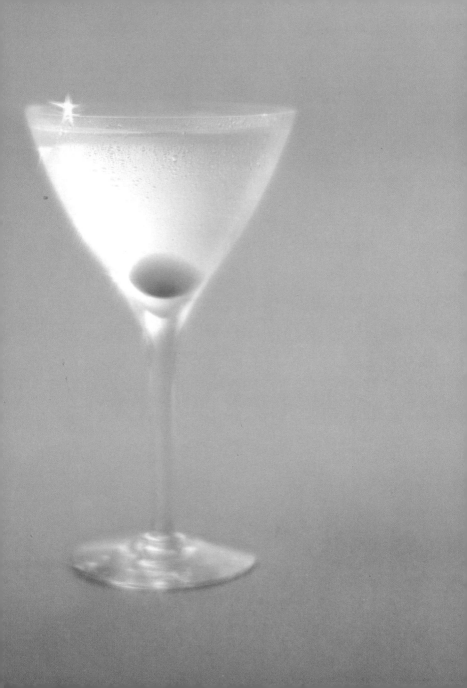

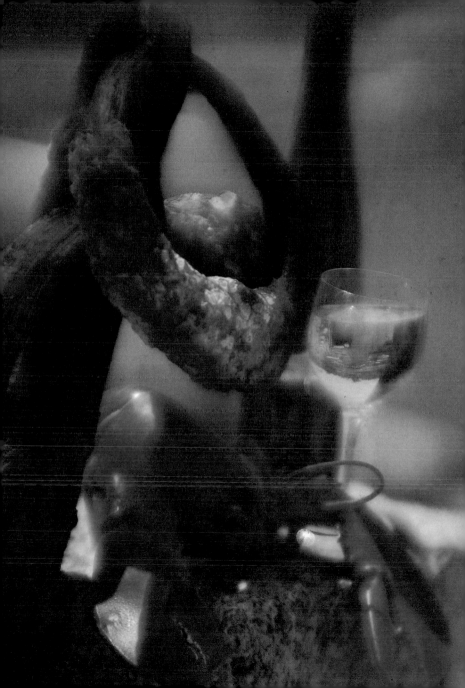

Principles of
Still-Life
Photography

Still-life photography is the only photographic form in which the photographer has total control over the picture. A good still-life photograph is the result of the thoughtful application of basic principles to the composition; a bad still life is the fault of no one but the photographer.

Photographers in general, and still-life photographers in particular, require a rudimentary working knowledge of chemistry, physics, mathematics, optics, art history, composition, color and light, psychology, carpentry, plumbing, electronics, and house painting. Additionally, they should have strong backs.

As in any art form, a basic grounding in principles and techniques enables the photographer to concentrate totally on the idea, the mood, and the message so that the finished product can be created without undue worry about things such as f-stop, bellows factor, lighting techniques, and mechanics of the equipment.

The purpose of this book is to acquaint the photographer with the principles and practices of the craft of still-life photography. We'll cover basic equipment, specialized equipment, and how to build easily some of your own studio equipment. We'll cover basic and advanced lighting, exposure and tone control (for black-and-white and for color), view camera technique, macro photography, set building, and a few surprises.

What are the most important factors involved in producing a good still-life photograph? Basically, they are to determine what you wish to say and to whom, to decide what mood you wish to express, and then to plan for the greatest visual impact through the use of composition, lighting, choice of lens and camera, props, background, and if necessary, photographic trickery. Having done all of that (and it's not easy), then stop and think. What can you add or take away to give the photo that little something extra that will make it uniquely yours?

Individual style is just that—*individual*. No two photographers would come up with the same still-life photograph if given the same elements and asked to illustrate the same concept. However, the same fundamental principles of composition would be found in both pictures.

Let's take a hypothetical example. The assignment is to create an interesting black-and-white photograph to adorn the walls of a family room. Whom are we appealing to? In this case, it is a family with children whose interests encompass golf, billiards, dominoes, and doll collecting. The family room has a bar. Based on this information, let's pick our props: for the doll collector, an antique doll; for the drinkers, a pilsener glass; for the billiard player, a ball (let's use a light-colored ball to convey a fun feeling); for everyone, either a pack of cards or some dominoes. The mood we wish to express is light, suggesting fun; we're looking for a high-key effect, with a light, airy background and no heavy or ominous-looking shadows. But what about that something extra? Perhaps it's as simple as inverting the pilsener glass and positioning it so

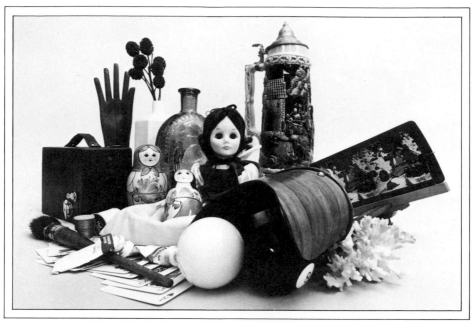

The same elements, differently arranged, will create different moods in a still-life photograph. Here, the overall mood is happy. The light is even and there are no harsh shadows.

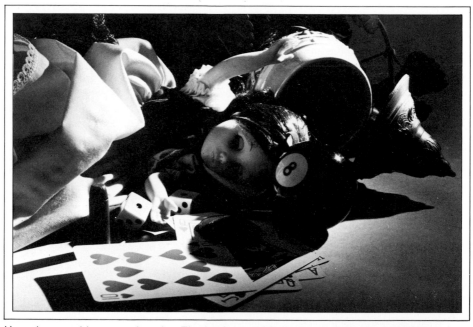

Here the mood becomes heavier. The background is darker and the shadows more obvious. The somewhat disordered composition suggests unhappiness and chaos.

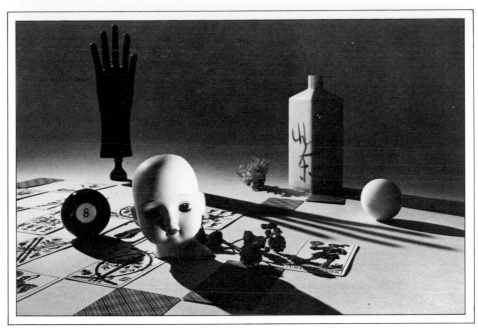

By isolating each element and lighting to create harsh shadows, a surreal composition is created. The effect is unsettling.

that it looks like a dunce cap on the doll. Often the little something extra is unplanned and happens spontaneously.

Now let's use the same props to express a completely different mood: debauchery—the evils of gambling, drink, and womanizing. The mood is heavier, almost sinister, so a dark background is indicated. The lighting should be considerably more contrasty. The doll's head might be removed from its body or the clothes might be removed from the doll, the poker chips could be scattered or stacked precariously, the billiard ball might be changed to an eight ball, and the pilsener glass could be tipped over or even broken. For the little something extra, perhaps some makeup could be applied to the doll's face.

To take a further example of how some of these same props could be used to express an even different emotion, let's make the scene surrealistic. You could take the playing cards and use them as a table surface, perhaps even using just one suit of the pack. Use all of the billiard balls and the doll's head in the traditional triangular racking position, and then create an artificial horizon.

A comparison of the illustrations shows how a small change in the elements of a still-life photograph completely changes the mood the picture expresses.

The potential of still-life photography is limited only by your imagination aided by your skill. Now it's time to proceed with the sometimes tiresome chore of practicing photographic scales.

The elements of a still-life can be selected and arranged to create a unified design.

2

Basic Equipment

To shoot successful still-life photographs, you obviously need a camera and lenses. But beyond that there is a wide choice of exposure meters, camera stands, lights, electronic flashes, and close-up equipment, either purchased, adapted, or do-it-yourself.

CAMERAS AND LENSES

To simplify matters, this section has been divided into three groups: the 35mm format, the 2¼-inch format, and the 4″ × 5″ view camera format.

Some cameras are better suited for still-life photography than others. View cameras have the greatest obvious advantages: their increased film size permits greater resolution of fine detail, the swings and tilts allow practically unlimited distortion and focus control, and the use of sheet film allows for greater darkroom control of a particular situation. The disadvantages are that they are heavy (although this is not serious, since most still-life work is done in a studio), they are slower to use, and the range of lenses available is more limited in scope than that of the other two formats.

The 2¼-inch and 35mm formats have many similar advantages: they are lightweight, quick to use (the 35mm a bit more so than the 2¼-inch), and more suitable for ultra-close-up work. A greater variety of lenses is available, and with the addition of an accessory bellows many of the features found in view cameras are possible. The 2¼'s prime advantage is in black-and-white photography, where the increased film size improves the overall relative sharpness of the pic-

ture. I feel that the 35mm is a better color camera, particularly when using a high-resolution film such as Kodachrome. Most color films available in the 2¼-inch format just don't seem to be able to match the quality found in Kodachrome. Another disadvantage in the 2¼-inch format is the lack of fast lenses. Although relatively unimportant in studio work, this is a drawback if you wish to use the same camera for general photography. The primary disadvantage of the 35mm format is its inability to render very fine, very small areas of detail on a small portion of a picture, either in black-and-white or in color. The film generally doesn't have sufficiently small grain to render this detail well.

35mm format. The basic equipment list for the 35mm format includes the following items:

A 35mm single-lens reflex camera (with or without a through-the-lens meter) preferably with double-exposure capabilities. Automatic-exposure single-lens reflexes are not recommended unless the camera has a manual override. An alternate choice of 35mm camera is a rangefinder camera with an accessory reflex housing, such as the Leica with a Visoflex. This system is limited in scope, however, as there are really no wide-angle lenses designed to fit these accessory housings.

A 50mm or 55mm macro lens capable of 1:1 magnification is a basic normal-focal-length lens. An alternate choice is a 50mm or 55mm lens with either a set of extension rings or some close-up lenses. If you use close-up lenses, then you should have at least the + 1, + 2, and + 3

diopter close-up lenses. A wide-angle lens, either a 28mm or 35mm, is also recommended. For a long-focus lens, either an 85mm or a 105mm is a good choice.

The *ideal* equipment list for the 35mm format also includes an ultra-wide-angle lens (20mm or 24mm) and a telephoto lens (135mm or 200mm). As an alternate to a normal macro lens, a 100mm or 105mm macro lens capable of 1:1 magnification can be used. The advantage of these lenses over the 55mm macro is in very close work. Because the focal length is doubled, you are twice the distance from the subject. This is a great advantage, as it gives you room to position the light in front of your subject.

A 35mm perspective-control lens is specialized but useful. It is designed primarily for architectural subjects so that the parallel, vertical lines of tall buildings can be maintained when the photographer is shooting from a close vantage point. Still-life photographers have found this same feature to be extremely valuable when photographing from high angles. Additionally, use of the perspective controls can effectively increase depth of field.

2¼-inch format. Any discussion of the 2¼-inch camera format becomes a little confusing because these cameras are available in two formats: 6 × 6 centimeters and 6 × 7 centimeters. Clearly, the advantage of the 6 × 7 format is the rectangular frame, which allows more flexibility in composition. Because the frame is larger, the lenses for the 6 × 7 format must be somewhat longer than those for the 6 × 6 format to provide the same angle of coverage. The accompany-ing chart gives the focal lengths for the recommended basic lenses for both these formats.

For close-up work, a set of extension tubes or a series of close-up lenses similar to those for the 35mm format is useful. Hasselblad makes a 120mm lens designed primarily for macro work.

A great advantage of the 2¼-inch format is the availability of interchangeable film backs. This makes it possible to switch from color to black-and-white film simply by switching backs. In addition, a Polaroid film back can be used, giving you an instant way to check cropping and lighting. Do not, however, use a Polaroid back to check color exposure, since the film will not give representative results.

4″ × 5″ view camera format. In still-life photography, the 4″ × 5″ view camera is the ideal format. Although these cameras are large, heavy, and slow, they also provide great flexibility and allow the use of large film sizes. The basic equipment list for a view camera includes the following:

Any 4″ × 5″ view camera with front and back swings and a rising and falling front standard is excellent. A camera with extra-long bellows is helpful when doing extreme close-ups.

In this format, a wide-angle lens is 105mm or 120mm, and an ultra-wide-angle lens is 65mm or 75mm. A normal focal length is 150mm, a long-focus lens is 210mm, and a very-long-focus lens is 300mm.

Close-up lenses and extension rings are not needed when using a view camera, as the extra-long bellows performs their functions. For close-up work, it is often better to use an 8″ × 10″ view camera

Lens	6 × 6	6 × 7
ultra-wide-angle	40mm	50mm
wide-angle	50mm or 60mm	65mm or 75mm
normal	80mm	95mm, 100mm, or 127mm
long-focus	250mm	250mm or 300mm

with a 4″ × 5″ reducing back. This gives a bellows extension of 32 inches, and with an 8-inch lens it gives a magnification of three times.

A problem often encountered when using ultra-wide-angle lenses with a view camera is too little space between the front standard of the camera and its back. This can make it impossible to focus at infinity; if infinity focus *is* possible, there may be too little space to allow the use of the standard swings and tilts of the view camera. This problem can be solved by using a recessed lens board, in which the lens is mounted approximately 1 inch behind the usual lens plane. It rather resembles an enlarger lens cone in reverse.

As with the 2¼-inch format, a Polaroid film back is a handy tool for checking light, composition, and cropping. Polaroid Type 55 P/N (positive/negative) is a fairly good film. If you use sheet film rather than 120 roll film, you should have at least six film holders.

EXPOSURE METERS

What type of exposure meter should you use? There are pros and cons for each.

Incident-light meters. This type of meter reads the light falling on the subject. The primary advantage of using the incident-light meter is that it measures the midrange of the photographic scale (18-percent gray or Zone V). This type of meter was originally developed for use in the motion-picture industry, where consistent flesh-tone exposures are required. Many incident-light meters have as accessories flat incident disks used to measure and note lighting contrast ratios.

The only disadvantage of incident-light meters is that they measure illumination only, not luminance or subject brightness.

Reflected-light exposure meters. These meters read the light reflected from the photographic subject just as the through-the-lens meters of most 35mm and 2¼-inch cameras do. This enables the photog-

rapher to determine the luminance range of the subject. A reflected-light meter can be used in much the same way as an incident-light meter by taking the reading from an 18-percent gray card, but this means carrying an 8″ × 10″ gray card in your camera case. The main disadvantage of the reflected-light meter is that it demands a more subjective judgment by the photographer of what he or she wishes to be properly exposed; this can lead to mistakes.

Incident/reflected-light meters. Many of today's exposure meters combine the features of both types of meters, while using the same exposure scale. Some even have 7½-, 10-, or 15-degree spot-meter attachments. The primary advantage of this type of meter is its ability to make dual readings, enabling you to determine your exposure based on greater knowledge.

First, read the reflected light to determine luminance, and then take an incident reading of the primary subject. If the primary subject will be rendered either too dark or too light in relationship to the rest of the photograph, either change the lighting or allow for later darkroom manipulation of the film. (We'll cover metering in greater detail in Chapter 4.)

One-degree spot meters. These meters are essentially telephoto reflected meters. They allow the photographer to determine more accurately the luminance from small details or to determine the luminance from a greater distance. In a sense, the difference between a general reflected meter and a one-degree spot meter is the difference between a shotgun and a rifle.

Strobe meters. Strobe meters are designed to read light from electronic flashes or flashbulbs. These meters are invaluable both in the studio and when using flash fill outdoors. Most strobe meters are of an incident/reflected type, and some have a provision for adding a 10-degree spot-meter attachment. Although some strobe meters are highly sophisti-

The Spectra® Tricolor meter.

cated and expensive, there are some very good, inexpensive strobe meters.

Color temperature meters. Color temperature meters that are sensitive to three colors are a luxury, but they are particularly helpful to the photographer who often shoots with available light such as fluorescent, mercury-vapor, or sodium-vapor lamps, all of which can give very unusual color results. The Spectra Color Temperature Meter is rather large, very delicate, and quite expensive; the Minolta Color Meter II is palm-sized, easy to use, extremely accurate, only slightly less expensive, and at this time almost impossible to find in any store.

There are very inexpensive color temperature meters sensitive to only two colors. In my professional judgment, they

probably aren't worth the space in your camera bag.

CAMERA ACCESSORIES

A sturdy tripod, preferably one with a side arm for low-angle shots, is one of the most valuable pieces of equipment you'll ever own. Don't scrimp on the cost of your tripod; it's a false economy. However, don't overdo it either. A tripod designed for an 8″ × 10″ view camera is not necessarily the best choice for a small 35mm single-lens reflex camera; in fact, it may be completely wrong for it. Go to the largest photographic supplier in your area and try out all the tripods. Place your camera on the tripod; jiggle it and see how long it takes to stop vibrating; extend

all the legs and the centerpost and try the vibration test again. If possible, shoot some tests at slow speeds and look for camera movement on the frame. A good tripod may be a bit expensive, but it's worth it.

Once you have a good tripod, you might consider getting a camera clamp with a ball head and a tabletop tripod. The camera clamp is a handy tripod substitute, allowing you to clamp the camera to a table edge, door, windowsill, tree branch, fence, or the like. A tabletop tripod is useful for low-angle shots. Outside the studio, it can be held against your chest or against a wall for steadiness.

In addition to the basic equipment already discussed, any or all of the optional equipment listed below will make your still-life work much easier.

Locking-type cable release.

Right-angle viewfinder for vertical or horizontal low-angle shots.

Spirit-type level—either a straight level, an adjustable one with a degree scale (valuable when adjusting the camera so that it is parallel to an inclined plane), or a dual level that attaches to the hot shoe of the camera. Some tripods are supplied with levels.

Tape measure marked in inches and centimeters.

Ruler marked in inches and centimeters.

Filters for black and white (medium yellow, medium green, and red).

Filters for color (see Chapter 4).

Gelatin-filter holder.

Polarizing screen.

Pocket calculator, preferably with square-root capability.

Photographic notebook.

CLOSE-UP EQUIPMENT

For complicated close-up still-life work, some specialized equipment is needed.

Bellows attachments. These attachments are generally for ultra-close-up photography. They range in quality from the simple, inexpensive T-mounted bellows with a focusing rack to the very elaborate assemblies for specific cameras. The latter can incorporate automatic lens coupling, close-up exposure compensation scales, camera tracks, front and rear focusing, and limited view camera swings and tilts that allow for distortion correction and focus control.

Bellows lenses. These short, mounted lenses of various focal lengths do not have focusing mounts. They are specifically designed for use with bellows attachments. Bellows lenses can be purchased, adapted from your enlarger lens, or made. In any case, they expand the range of possibilities, allowing options of creativity not available with the standard lenses generally supplied by most manufacturers.

Camera tracks. Camera tracks allow you to focus the camera by moving it, not the lens. When shooting extreme close-ups, focusing with the focusing mount or the bellows is very difficult, as racking the lens forward or backward changes the magnification, not the focus. The alternative is to preset the focus of the camera to the desired magnification and then to move the camera backward or forward until sharp focus is achieved. Since moving the camera and tripod by millimeters is virtually impossible, the solution is to mount the camera on a geared track which is then mounted on the tripod. A second track mounted at right angles to the main track makes lateral movement more controllable, although this rig is not very steady.

Split-diopter lenses. These lenses are a variation on close-up lens attachments. In effect, they are close-up lenses cut in half. One half of the lens is clear; the other half is a close-up lens, allowing the photographer to have two planes of focus in the same shot.

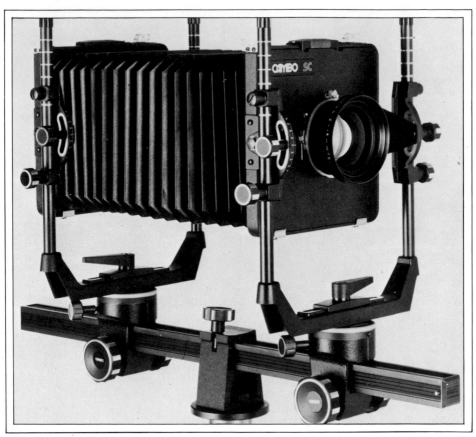

Shown here is a Cambo 4 × 5-inch view camera, mounted on a focusing rail. Note that the focusing rail allows for vertical and horizontal movement, and for swings and tilts.

LIGHTS

In still-life work, the photographer has total control over the light, the basis of all photography. Discussed below are the types of lights found in most photographic studios.

Tungsten lights. Tungsten lights are lightbulbs used in floodlamps. The best are the quartz-halogen bulbs, because they remain bright and give consistent color throughout their lives. A less expensive alternative to quartz-halogen bulbs is reflector floodlights (photofloods). These bulbs are manufactured with a built-in reflector. They are suitable for all types of studio work, but they should be changed

fairly often, because their color temperature becomes warmer the longer they are burned. Blue photofloods should be avoided; the blue coating is unstable, resulting in unpredictable color.

Two or three floodlamps, of whatever type, are sufficient for nearly all studio situations.

Mini-spots. These are smaller light units, with an output of 150 watts, that allow the light beam to be controlled from a broad flood to a rather narrow, angled spot. Two or three mini-spots with quartz-halogen bulbs will provide excellent lighting control. To further narrow and angle the beam, long tubes called snoots can be attached to the front of the

mini-spot. Barn doors (adjustable flaps that block off the side spill of the light) are also used to alter the shape of the beam. For special-effects photography, adapters to hold colored gel filters can also be attached.

Electronic flash units. These flash units are available in many different forms. When making your choice, look for a unit with an attached modeling light. A low-wattage tungsten bulb mounted in the reflector of the flash head, the modeling light visually approximates the light from the flash, allowing you to previsualize the effect.

The ideal flash unit is a studio strobe with a light output of between 400 and 1200 watts. These units usually accept four or more light heads, but they are extremely expensive. Smaller units with modeling lights, of the type used by itinerant school photographers and used as location lights by industrial photographers, are cheaper. They have an output of about 240 watts and usually accept up to three light heads.

An alternative to studio strobe units is two or three portable, battery-powered units with slave triggers. Many of these units are available with adapters for household current, and many accept accessory modeling lights.

To calibrate your modeling light so exposures can be determined from a regular ambient-light exposure meter, use this procedure:

1. Place a gray card and gray scale 5 feet in front of the camera.
2. Place the flash to the left or the right of the camera so that the light strikes the gray card at a 45-degree angle.
3. Shoot a bracket of exposures of this setup using your guide number as your base of exposure.
4. Process the film and determine the best exposure.
5. With the flash and modeling light in the same position, turn on the mod-

eling light, set your incident-light meter to the film speed you are using, and take an incident-light reading of the gray card.
6. Now determine what shutter speed coincides with the predetermined aperture of your best flash exposure. If your best flash exposure was $f/8$, the indicated shutter speed might be 4 seconds. For your flash unit, then, 4 seconds would be your flash coordinate.
7. Now, when using the modeling light, all you have to do is read the modeling light with your ambient meter and set the dial. Whatever f-stop is indicated adjacent to the 4-second mark is the f-stop you should use with your flash. If you have more than one strobe, each with its own modeling lamp, the 4-second point will still apply.

Do not use this method of exposure determination if the surrounding area is brightly lighted. Turn off the lights if at all possible. This system does not work with automatic flash sensors. If you have an auto-exposure unit, use it in the manual mode.

Fluorescent lights. These lights are not generally recommended for color photography because of color distortion. (Refer to the Appendix for color-correcting data.) For black-and-white work, a very efficient $2' \times 2'$ bank can be constructed by mounting 2 ceiling-type, four-bulb, fluorescent-tube units together. This size bank is normally large enough for most small still lifes, but it is bulky and hard to move around.

Alternate lighting equipment. This lighting category basically encompasses anything your ingenuity can devise. A high-intensity desk lamp is an excellent source of concentrated light, particularly valuable when shooting close-ups. A slide projector makes an excellent spotlight; it can be used to create special

effects by projecting sharp geometric forms onto a set. Fiber-optic light sources are a good solution for lighting extreme close-ups, as they can be bent around corners and placed where no other lights will fit. These units are available from scientific supply stores.

Reflector floodlights. These tungsten bulbs of either 250 or 500 watts are an inexpensive way to get a lot of light onto a set. A large light bank can be made easily with porcelain sockets, a bit of wire, and some wooden supports. To eliminate the multiple shadows caused by a bank of bulbs, hang a sheet of frosted plastic in front of the bulbs to act as a diffuser.

In addition to the lights, you will need light stands and light clamps. Six light stands and three or four alligator-type light clamps are usually sufficient for most applications.

When buying lighting equipment, a camera store is a good source. An excellent but little-known source for lighting equipment is the theatrical supply store. Such stores generally carry a great variety of lights useful to the photographer, and the price may be lower.

DIFFUSING EQUIPMENT

A major problem in still-life photography is softening the light to avoid harsh shadows and unwanted reflections. The usual technique of placing a handkerchief over the flash unit or bouncing the flash off the ceiling is fine for snapshooting, but not very effective in a studio situation. However, some basic diffusing equipment is relatively inexpensive to buy at art-supply stores, and some of it can be made easily.

Reflectors. Reflectors are used to lighten shadows, reduce contrast, and redirect light. A reflector can be anything that reflects light, but in practice it is usually a fairly shiny, flat, white surface, such as a sheet of white poster board. In an emergency, even a white shirt can be used.

Umbrellas. These diffusing items attach in front of the light unit. They generally are made of a translucent material that gives broad, diffused light. Standard equipment in many studios, umbrellas come in a variety of sizes and shapes.

Soft boxes. Soft boxes are in essence

Umbrellas can be either silvered or white. Shown here is an umbrella being used with a flash head.

large, enclosed light reflectors with diffusers. They effectively increase the size of the basic light source relative to the subject and give a fairly soft light that seems to wrap around the subject. A soft box that is 3 feet square is probably the best size for most tabletop still lifes. Soft boxes work particularly well with electronic flash. When used with tungsten lights, however, the diffusing plastic will yellow over time.

BACKGROUND LIGHTING ACCESSORIES

Seamless background paper. Useful for creating backdrops to still-life setups, seamless background paper is available in various colors and comes in long rolls that are 9 feet wide (some suppliers have rolls that are half that width). For small sets, 30″ × 40″ artist board makes an excellent seamless background.

Tents. Tents are particularly valuable tools when photographing reflective objects, particularly silver or chrome. Small tents can be created simply by encircling the set with white cloth or seamless background paper and shining the light through the tent. A small, temporary tent can be constructed quickly by scoring a large piece of foam-core board, bending it into a U shape, and placing it around the set. Because this sort of tent must be lighted from within, it is called a *bounce tent.* The drawback is that reflections often appear on the surface of the object being photographed.

A more permanent tent of any size can be made by building a wooden frame and stapling a white, translucent material (either white, seamless background paper or cloth) to it. Set up the frame so that the material faces the subject; otherwise, reflections of the frame will appear in the photograph. The advantage of building a frame tent is that a roof can be placed on it if needed.

Light cones. These are permanent miniature tents made of a thin sheet of opalized plastic shaped into a cone. They are ideal for photographing jewelry and other small, highly polished objects. Only one light is necessary, because the sloped, rounded sides both transmit and reflect the light. Since there are no corners, a light cone is an almost perfect lighting source.

Sweep tables. A sweep table provides an excellent background for shadowless light. Basically, a sweep table is made of curved, opalized plastic that can be lighted from behind and below.

HOMEMADE SOFT-FOCUS LENS

A useful item of equipment that is easily and inexpensively made yourself is a soft-focus lens. You need a T-adapter, a Series VII reverse adapter, a Series VII + 10 diopter lens, and a bellows attachment. Mount the + 10 diopter lens into the reverse adapter and then attach it to the T-adapter. Mount this assembly onto the bellows and you're ready to shoot. The + 10 diopter lens will give a soft-focus lens of 100mm with an aperture of about *f*-2. Since this is an extremely simple lens, it will produce aberrations of every sort, especially flare. Determine exposure by using the camera's through-the-lens meter.

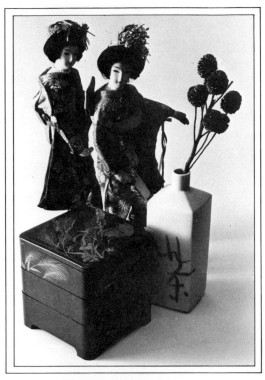

The light in this shot comes from a window on the left. The shadows obscure the details of the dolls.

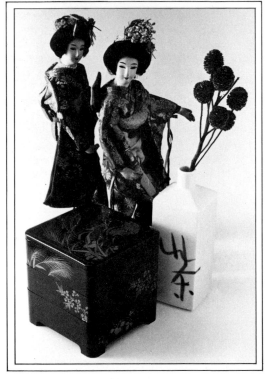

A reflector has been placed to the right of the dolls, eliminating the shadows and bringing out the details.

3

Basic Lighting

A photographer friend once called me for help. He had lighted a still life of two brandy bottles and two glasses of brandy using two lights. To quote him, "They looked like stone," so he redid the shot with three lights. It looked worse, so he tried it with four lights. Then he called me. My approach was to shine one light onto the white background, masking it so that no direct light was reflected in the bottle. I then placed two tall, white reflectors on either side of the camera.

The point I wish to make is that lighting should be simple. Whenever possible, try to use one light either direct or bounced from a large reflector.

To start with, let's demonstrate a one-light situation using light from a window.

Now let's add a white-card reflector.

Although I've said that lighting should be simple whenever possible, I'm going to muddy up the waters and get very technical. First, let's define some terms used to describe light.

Candela is the term now used as the internationally recognized standard unit of measurement of luminous intensity. It is 0.98 of a standard candle (the candle referred to in footcandles).

Luminance or brightness is a point (specular) source of light (e.g., the filament of a lightbulb) that exhibits great luminance but has little intensity.

Intensity is determined by multiplying luminance (candelas) by the area. A lamp filament emitting 1 candela of luminance is very bright to look at, but if the same filament were placed in the center of a circular room having a radius of 20 feet, the intensity of light striking the walls 20 feet away is only 1/400th of a candela.

Lumen is the term used for the measure of luminous energy emitted by a light source. A lumen is the amount of light that would reach a 1-foot-square section of a sphere with a radius of 1 foot if a light source emitting 1 candela of intensity were placed in the center of the sphere. One lumen is equal to 1 footcandela; the terms are virtually the same.

For a listing of light sources and their intensities, refer to the Appendix.

Light from a point source of light is emitted equally in all directions. As a result, as the distance from the point source to the subject increases, the light must cover an increasingly larger area, and the amount of light falling on the subject decreases. This diminishment occurs in the proportion to the inverse square of the distance. This concept, known as the inverse square law, means that if the distance from the light to the subject is doubled, the intensity of the light falling on the subject will be only one quarter as strong. If the distance is tripled, the light intensity will be reduced to one ninth. The reverse applies as well. If the distance between the light and the subject is halved, the light intensity will be quadrupled.

The falloff of light from a point source has important ramifications for the studio photographer. Let's assume we have a set that is 1×1 foot. We want to light the set from the left side, and we want that illumination to be 4 candelas in intensity. A light of what intensity placed how far away will illuminate the set with 4 candelas? In addition, what will be the light falloff from the left edge to the right edge of the set?

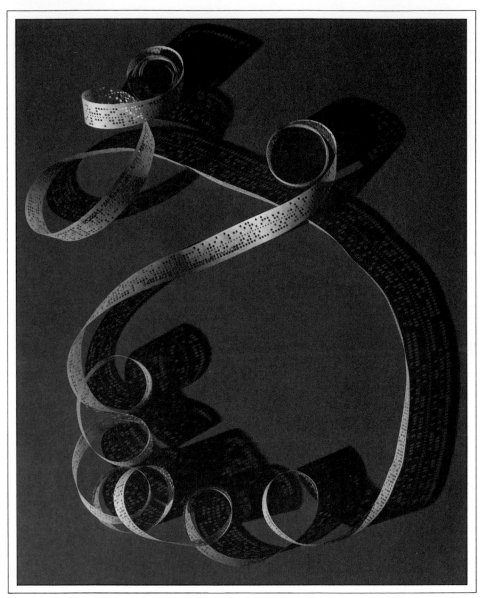

To get sharp-edged shadows from this strip of computer tape, a 1,000-watt spotlight was placed about ten feet away, at a 20-degree angle above the surface.

Two lights were needed to create the effect of light fall-off in this shot. A 2,000-watt spotlight was aimed directly at the figure from a very low angle. A second 1,500-watt floodlamp was aimed downward to bounce light from the seamless background paper

To find the answers, we'll use variations on the formula that illumination (in footcandelas) equals the intensity of the light divided by the distance to the subject (in feet) squared.

First, we'll determine how intense a light is needed at various distances from amount of light falloff, we'll then divide the intensity of the light needed to give 4 candelas of illumination on the left edge by the square of the distance from the light source to the right edge. As the chart below shows, this is less complicated than it sounds.

Distance in feet	Distance squared	×	Illumination 4 fc.	=	Intensity
1	1		4		4 fc.
2	4		4		16 fc.
3	9		4		36 fc.
4	16		4		64 fc.
5	25		4		100 fc.
10	100		4		400 fc.

the left edge of the set to maintain an illumination of 4 candelas on the set. To find the intensity, find the square of the distance between the light and the subject and multiply it by the illumination desired (in this case, 4 candelas). The accompanying chart shows the results.

The next step is to determine the amount of light falloff from the left edge of the set to the right edge. We'll do this by calculating the amount of light falling on the right edge of the set using the same formula as we did for the left edge. (Remember, the set is 1 × 1.) To find the

As you can see, the falloff of light from one side of the set to the other decreases as the distance from the light to the set increases. A studio large enough to place a light 100 feet from the set would have a light falloff across a 1-foot set of only 2 percent, a negligible loss.

In the discussion above, we've dealt only with light from a bare bulb. A reflector would have the effect of directing more light onto the subject, but how much more would depend a great deal on how large the reflector is and of what it is made.

Distance from light to left edge of set	Distance from light to right edge of set	Distance to right edge squared	Intensity of light source needed for 4 candelas	Square of distance ÷ to right edge	Intensity of illumi- = nation on right edge	Difference between left and right edges	Percent of light on right edge	Differ- ence in f- stops
1 ft.	2 ft.	4 sq. ft.	4 fc.	4	1 fc.	3 fc.	25 %	− 2
2 ft.	3 ft.	9 sq. ft.	16 fc.	9	1.78 fc.	2.22 fc.	44.42%	− 1¼
3 ft.	4 ft.	16 sq. ft.	36 fc.	16	2.25 fc.	1.75 fc.	56.25%	− ⅞
4 ft.	5 ft.	25 sq. ft.	64 fc.	25	2.56 fc.	1.44 fc.	64 %	− ⅔
5 ft.	6 ft.	36 sq. ft.	100 fc.	36	2.78 fc.	1.22 fc.	69.25%	− ⅔
10 ft.	11 ft.	121 sq. ft.	400 fc.	121	3.3 fc.	0.7 fc.	82.5 %	− ⅓

The goal here was to simulate sunlight streaming through a window. A 1,500-watt floodlamp was placed outside the "window" in the studio set and aimed at the sheer curtains to diffuse it. A card reflector was placed to the left to soften the deeper shadows.

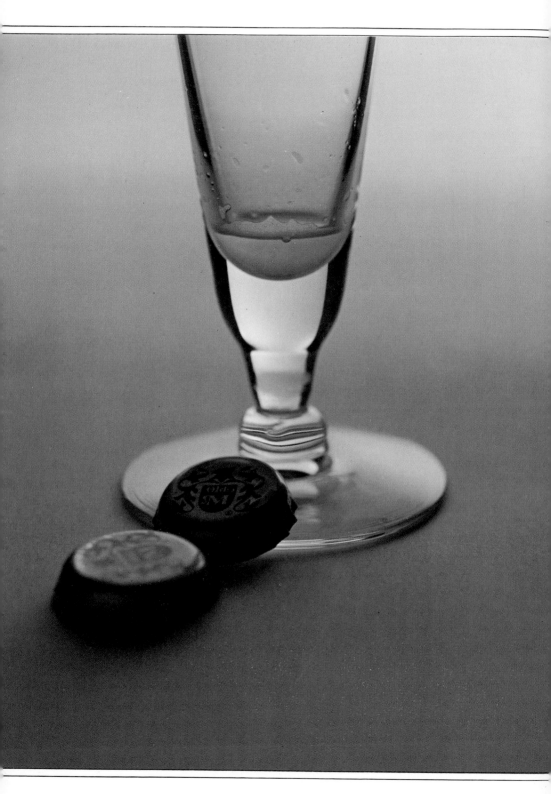

In practice, if you wanted a prop on the left and a prop on the right of your set to be evenly illuminated each prop would have to be individually spotlighted and each would have to be the same distance from its respective spotlight. This type of lighting is rarely called for.

After point-source lighting, the next step is to consider broad-source lighting. Just as with a point source of light, we can determine the necessary output or distance needed to provide the desired illumination when the source is a soft box or a bank light. The great advantage of a soft box is that it requires less intensity to give the same illumination than does a point source of light, and is equal to a specular light source at a greater distance. On the other hand, a soft box incorporates reflectors and diffusers, and their effect on the light must be considered.

Let's design a series of theoretical soft boxes of different dimensions using metallic reflectors with reflectance factors of 4 and diffusers with light-absorption factors of one-half stop, or 1.414. (Absorption factors are determined by measuring the light from the light source both with and without the diffuser. The difference between the two readings is the absorption factor.)

For the purpose of this discussion, imagine four different soft boxes of these dimensions: $2' \times 2'$, $3' \times 3'$, $4' \times 4'$, and $10' \times 10'$. To get even illumination on the front surface of the soft box, the depth of the box must be at least one half of the diagonal of the front surface. To determine the diagonal, use the Pythagorean Theorem: The square of the diagonal is equal to the sum of the squares of the two sides. For the $2' \times 2'$ soft box, for example, the square of each side is 4; add 4 and 4 to get 8; find the square root of 8 (2.83), and divide by 2. The result, 1.41, is how deep this soft box should be.

We'll assume that the reflectance factor of all our soft boxes is 4 and that the absorption factor is 1.414. To find the corrected factor, incorporating both factors, divide the reflectance factor by the absorption factor. In this case, 4 divided by 1.414 equals 2.82.

Now let's find out how intense the illumination of the soft box must be to give 4 foot-candelas of illumination on the left edge of our 1-foot set if the soft box is 1 foot from the set. Find the distance from the front of the soft box to the set, add to it the depth of the soft box, and square the result. Multiply this number by the desired illumination (4 footcandelas), and then divide this figure by the corrected reflectance/absorption factor. Once again using the $2' \times 2'$ soft box as an example, the calculation would be as follows: $(1 + 1.5)^2 \times 4 \div 2.82 = 8.86$ footcandelas.

In the photographs on pages 38–41 you'll see the difference between point-source light and soft-box light, and how the distance from the light to the subject and the angle affect the composition.

The best way to learn lighting is to do it. Practice, and then practice some more.

To get the virtually shadowless lighting of this shot, broad soft box lighting was aimed high up on the background area outside the frame of the picture. This produced a muted light while still giving bright highlights on the base of the glass.

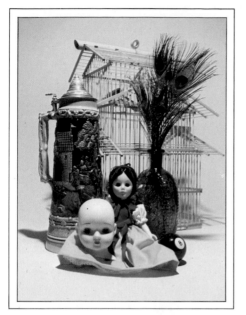

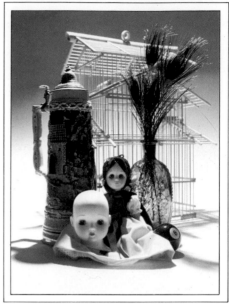

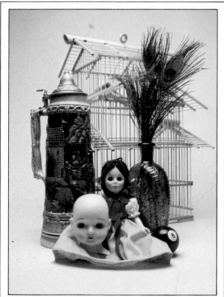

In this series of pictures, the differences between specular light and soft box light are illustrated. The picture on the upper left shows top frontal lighting using a point source of light such as a spotlight. Note the deep shadows under the eyes of the heads and the sharp shadows of the other objects. Top frontal lighting using a soft box is shown on the bottom left. The shadows are much less visible. In the shot above, the set was lit from the top rear by a specular light. The shadows are very pronounced, and light fall-off at the background is apparent.

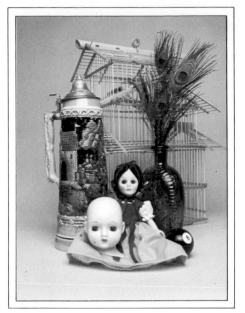

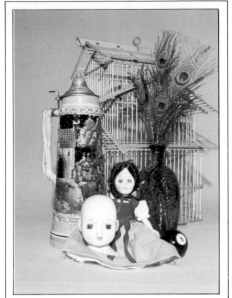

Above, soft box light from the left with a fill light is shown. The soft box reduces the shadows and gives more even illumination, aided by the fill light, especially in the background. The picture on the upper right shows specular light from the left side. In the picture on the lower right, a soft box placed to the left is used.

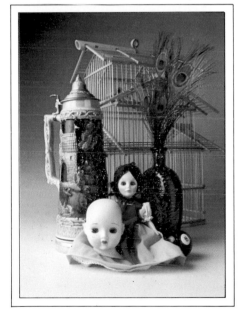

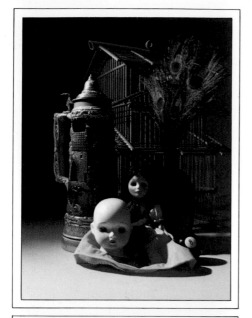

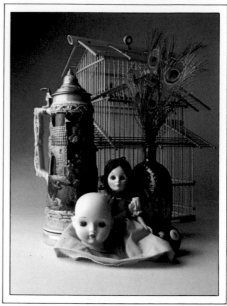

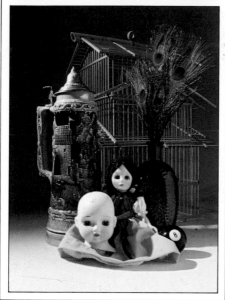

In the picture to the upper left, directional side light from a spotlight to the left of the set gives a dark background and noticeable light fall-off to the right, but highlights colors and textures on the left side of the set. Side light from the left using a soft box is shown above. The background is dark and there is light fall-off, but less so than with specular light. Specular light from the left with a smaller fill light gives a dark background and dark shadows in the picture at bottom left, but far less so than without the full light. Light fall-off is considerably reduced, but the bottle to the right is still dark.

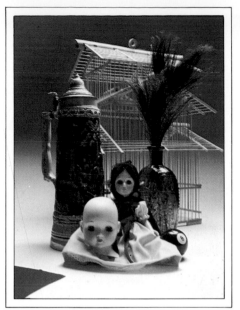

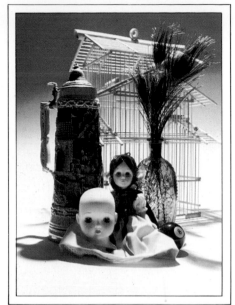

Top rear lighting using a soft box is shown above. The shadows are softened, but light fall-off in the background is greater and less detail is visible. A card reflector was used with top rear specular light in the shot at upper right. Though the effect is subtle, the shadows are somewhat lighter and more detail is visible. Top rear light with a card reflector using a soft box is shown at bottom right. The diffused light of the soft box plus a reflector gives more detail to the shot and brings out the textures of the objects.

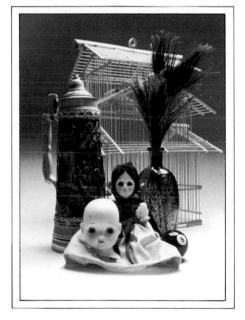

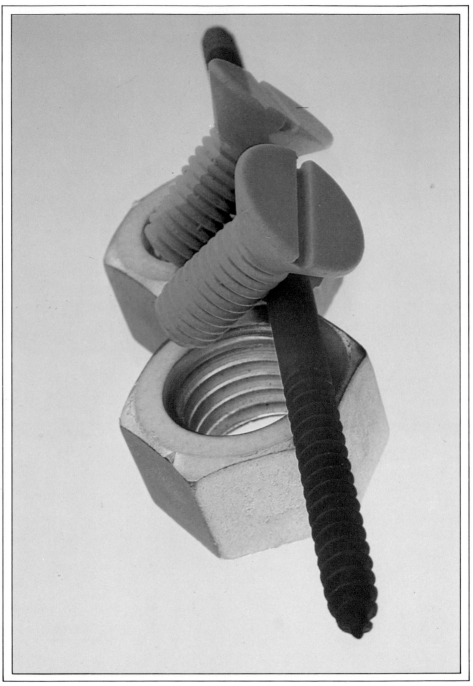

The nuts and bolts of photography. Bounced broad source lighting was used with a card reflector for even lighting and no glare from the nut; the green and red bolts were painted with fluorescent spray paint.

4

Exposure, Tone, and Color Control

One of the more important technical aspects of photography is exposure control and its relationship to tone and color control. A lot has been written on this subject, although much of it seems to be designed to confuse rather than to enlighten. By simplifying the explanation of tone control, I hope that some of this confusion and mystique can be easily dispelled.

EXPOSURE AND FILM

Most medium-speed black-and-white negative films and color reversal films have an average total luminance range of 256:1. That is, they have the ability to reproduce a tonal scale on the negative ranging from one unit of light for the darkest gray to 256 units of light for the lightest definable gray. When moving from each shade of gray to the next lightest shade, the units of light striking the film are doubled. If the darkest shade of gray is created by 1 unit of light, the next lighter shade is created by 2 units, the next lighter shade after that by 4 units, and so on through 8, 16, 32, 64, 128, and 256 units. Since *f*-stops use the same concept of doubling the amount of light, the luminance range is the equivalent of 9 *f*-stops, or 11 *f*-stops if pure white and pure black are included. In practice, however, the *effective* luminance range of most films (the ability to reproduce dark and light gray with *texture*) is only 16:1, or 5 *f*-stops.

When using color slide film, the units

of density are reversed, but the negative stage is the determining factor for tone control.

There are times when the luminance range of the subject exceeds the film's ability to record it, requiring the photographer to contract the tonal scale of the film. There are also times when the luminance range of the subject is less than the film's range, and the tonal scale must be expanded. Methods for accomplishing these feats of photographic magic will be explained later in this chapter.

EXPOSURE METERS

In both color and black-and-white photography, reflectance-type meters are calibrated to read midrange exposures, those which reflect 18 percent of the light falling on them. This is the midrange between bright snow, with reflectance of 81 percent, and deep but textured shadows with a reflectance of 4 percent. What this means in practical terms is that most light meters will indicate an average reading designed to reproduce the 18-percent gray range, regardless of the subject. Close-up meter readings of a black cat, or a field of snow, or someone's face would all indicate exposures that would be rendered on the film as 18-percent gray. A general reading of someone holding a black cat in a snow field would be correctly rendered, however, if it were taken with a normal lens. If you used a wide-angle lens that included relatively more of the snow field in the picture, the meter reading would be

This sequence shows the effect of lighting ratios. In this shot, the ratio is 2:1, with twice as much light on the left of the shot as on the right.

The lighting ratio here is 4:1. The colors on the right are less distinguishable.

As the lighting ratio becomes 8:1, the colors on the right become even less clear.

In this shot, the lighting ratio is 16:1. The colors on the right can barely be seen.

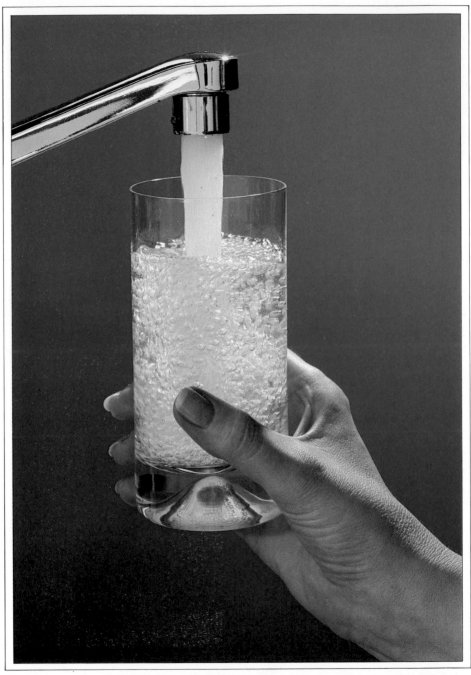

The green plastic sheet used for the background here was lit with one strobe directed through it. Direct backlight came from camera right; a strobe was also bounced from a foam-core tent in the foreground. Strips of green and black paper on the tent surface modulated the tones on the chrome faucet.

unduly influenced by the brightness of the snow and would indicate what is in reality underexposure. A similar situation is faced when photographing two people together if one is deeply tanned and the other has a very pale complexion. For which face should you expose to get an 18-percent reflectance? The answer is the tanned face, since pale complexions reflect about 35 percent of the light.

Clearly, there is more to using a reflectance-type light meter than just pointing it at the subject. A knowledge of the subject's reflectance qualities is also important.

Reflectance meters can be read in two ways. The simplest way is to take readings from the darkest and lightest areas in which texture must be rendered, and then to use an exposure halfway between the two. If the contrast range exceeds five f-stops (two f-stops darker and two f-stops lighter than midrange), then some form of contrast control will be needed unless you are willing to sacrifice some texture in the picture.

A second method, more complicated but also more accurate, is to use an 18-percent gray card, which is commercially available from Eastman Kodak. To find the correct midrange exposure using a gray card, place the card in the subject plane and angle it so that it is halfway between the light source and the camera. Then take the reading from the card. In an emergency, the palm of your hand can be used instead of the gray card. Since the palm reflects about 35 percent of the light falling on it, take a reading and double it for a fairly accurate exposure.

An additional use of the gray card is in determining lighting ratios. Set up the gray card as previously described and take a meter reading using just the main light. With the main light still on, turn on the fill light and read the gray card from the shaded side. The difference between the two readings is the lighting ratio. Generally, lighting ratios are between 2:1

and 4:1. In some cases, when subject contrast is low, lighting ratios of 8:1 or even 16:1 are acceptable. Conversely, if the subject contrast is very high, a lower lighting ratio might be needed. To determine the luminance of the subject, which incorporates both the contrast values of the scene and the lighting ratio, read the darkest and lightest areas requiring texture and average the results.

To find the midrange exposure reading using a through-the-lens meter, set up the camera and subject for the shot and focus the camera on the subject. Place a gray card on the subject plane angled halfway between the main light and the camera. Without refocusing, move the camera forward until the gray card fills the frame and take a reading from it.

Incident-light meters allow you to determine the midrange exposure for three dimensional subjects. A dome of translucent plastic is placed over the sensor of the meter. The meter is placed at the subject position pointing toward the camera. The dome gathers light from the front, the sides, and the top, and indicates an integrated reading of all the light falling on the subject. An accessory supplied with some incident-light meters is a flat disk that replaces the dome and is used for measuring lighting contrast only. The method is much the same as that used with a reflectance meter and a gray card.

Dual meters that read both incident and reflected light are also available. Overall luminance can be read using the meter in the reflectance mode; the incidence dome can then be put on the meter and used to read the midrange.

Spot meters generally measure 1 degree of the reflected light, although accessory spot-meter attachments for general meters will give 7½-, 10-, or 15-degree readings. They are very helpful for isolating important areas for selective readings. Scenes that are not average—such as a small, dark subject on a large, bright area—are best metered with a spot meter.

Measure the lightest and darkest areas requiring texture and average the two readings for the correct exposure. It is important to remember that a spot meter reads only a small portion of each area, so in effect highlights and shadows are equally represented.

Strobe meters are designed to read the light from electronic flash. They are particularly valuable in the studio and when using flash fill outdoors. Most strobe meters are dual-reading types, and some have accessory spot-meter attachments.

CONTRAST CONTROL

When the contrast range of the subject is too long or too short to give a full-range print, there are four possible solutions to the problem.

The first and most obvious solution is to alter the lighting to match the luminance range of the film. This can be done in several ways, such as by adding more fill light or more reflectors. Alternatively, the main light can be broadened or softened by placing a diffuser larger than the light source between the light and subject.

A second way to control contrast is to manipulate the exposure and development times. In essence, this involves overexposing and underdeveloping the film to compact the luminance range, or underexposing and overdeveloping the film to extend the luminance range. The procedures for doing this are generally referred to as the Zone System, and they are really only effective in black-and-white photography. Some tone control can be done with color materials that can be processed in a home darkroom, but the results are usually disappointing.

The Zone System was first systematized by Ansel Adams in the 1930s. In this system, all the tones of gray in a black-and-white photo are divided into ten zones. Zone 0 represents pure black in the print, and consequently no exposure on the negative. The darkest shade of gray in the print is represented by Zone I; Zone IX indicates pure white. Each zone represents a one-stop exposure change on a standard gray scale. In a perfectly exposed and developed print of a perfectly

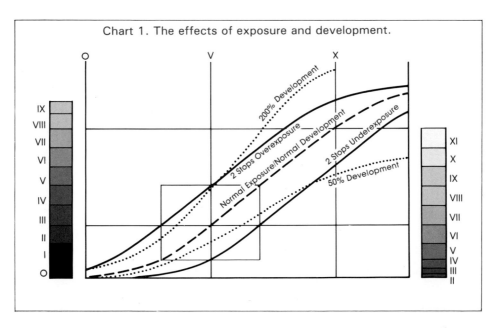

Chart 1. The effects of exposure and development.

average scene, all ten zones of the negative will be reproduced accurately when printed on normal-grade paper.

The normal textured luminance range of most films extends from Zone III to Zone VII, or two stops in either direction from the midrange Zone V (18-percent gray). When normal exposure is based on Zone V, Zones 0 and I show very little contrast, Zone II has a bit more contrast, and Zones III to IX have the most equal contrast.

But what if the contrast range of the subject doesn't match the film's ability to record it? The first step is to look at the scene and previsualize how you would like it to appear in the finished print. If you wish to increase contrast in the shadows, an overexposure is needed. A two-stop overexposure would increase the contrast in Zones O and I only slightly, but it would also increase the contrast range in Zones II through VIII, allowing more texture to be seen overall. If this overexposed negative is then underdeveloped, the tonal scale is further decreased and the luminance range is thus further expanded. Contrast in both the shadows and the highlights is lost, but differences in contrast between Zones IV and VIII are maintained almost equally.

Conversely, if there is too little contrast in the original scene, it can be underexposed and overdeveloped to provide a full contrast range. An underexposure of two stops will give a gain of two stops in the highlight area and will lose all detail in Zones 0 and I. Zones II and III will have very little contrast, Zone IV will have a bit more, and Zones V through VIII will have equal and greatest contrast. If the negative is then overdeveloped by 200 percent, for example, Zone 0 will be raised to Zone II, Zone I will lose detail and contrast, Zones III and IV will increase progressively, and maximum contrast will be found in Zones V through VIII. The contrast will fall off rapidly in Zones IX through XII.

Basically, then, if a scene has more contrast than the film is able to reproduce, overexposure and underdevelopment will compress the tonal range. Shadow tones in Zones 0 and I will be

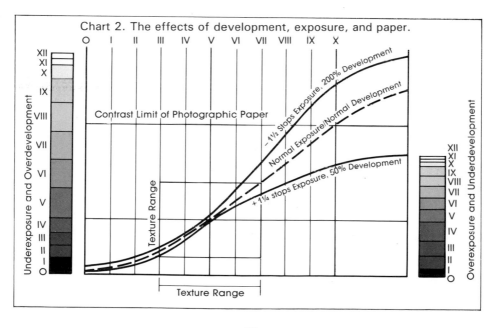

Chart 2. The effects of development, exposure, and paper.

increased, and highlight tones in Zones X and XI will be decreased.

If the scene has too little contrast, underexposure and overdevelopment will increase highlight detail. The accompanying chart gives the approximate exposure ranges of a film that has been manipulated by exposure and processing.

Development	Zones rendered
50%	12
75%	11
100% (normal)	10
150%	9
200%	8

Remember, however, that the normal range for reproducing *texture* extends from Zone III to Zone VII, or two stops in either direction from the midrange. This means that even if the unmanipulated print contains tones ranging over more than five zones, not all of them will have detail. By using the Zone System, the detail range can be extended, as the chart at the bottom of the page shows.

A third method of contrast control is to process the film to include the greatest luminance range (normal or 75-percent development) and then to print it on

Paper grade	Luminance range covered	Number of zones covered
0	1024:1	11
1	767:1	10½
2	512:1	10 (full range)
3	384:1	9½
4	256:1	9
5	192:1	8½

graded contrast paper. This method is particularly helpful for 35mm cameras, because the entire 36-exposure roll can be processed at once. The chart below shows the ranges a normal-density negative can cover with different grades of paper.

When making the print, the luminance range of a high-contrast subject can be further compacted by underdeveloping the negative and printing it on a low-contrast (grade 1) paper. If the subject is a low-contrast one, contrast in the print can be increased by overdeveloping the negative and then printing it on a high-contrast (grade 5) paper.

The fourth method of contrast control, pre/post fogging, can be used with both black-and-white and color films. A minimal exposure to light, either before or after photographing the subject, has the effect of reducing contrast in the shadowed areas with little effect on the midrange tones and practically no effect on the highlights. Pre/post fogging is particularly valuable when using films that must be processed by an outside lab.

When using an incident-light exposure meter, use this procedure for pre-fogging.

1. Read the incident light falling on an 18-percent gray card.
2. Position the camera so that the gray card fills the frame.
3. Focus the camera on infinity so that any texture on the gray card is out of focus.
4. Using the incident reading as a base, take a picture of the gray card, underexposing by three or four *f*-stops. In extreme cases underexpose by two *f*-stops.
5. Prepare your camera for a double

Development time	Texture range in *f*-stops	Luminance range in *f*-stops	Zones with textures	Total
50%	−4 to +3	8	I to VIII	0 to XII
75%	−3 to +3	7	II to VIII	0 to XI
100% (normal)	−3 to +2	6	II to VII	0 to X
150%	−2 to +2	5	III to VII	0 to IX

exposure. (See your camera's instruction manual for directions.)

6. Meter the still-life setup in the usual way and shoot it normally on the preexposed frame.

For post-fogging, follow the same procedure but shoot the scene first and fog the film afterward.

When using a reflected-light exposure meter, follow the same procedure, but take the initial reading directly from the gray card.

A pre/post fog of four stops underexposure raises the tones of Zone I to Zone II (a one-stop increase) while increasing exposure in Zone V by only one-sixteenth stop. A pre/post fog of three stops raises Zone I to Zone II½, with an increase of only one-eighth stop in Zone V.

Pre/post fogging can also be done with colored filters. The procedure is the same, but remember to include the filter factor in the pre/post fog exposure.

COLOR CONTROL

As with black-and-white film, color film exposures are generally based on the mid-range of luminance (18-percent gray). However, because color film almost always must be processed by a commercial lab, exposure control using Zone System techniques is much more difficult.

In the shot on the left, the set was lit properly, but the green bottle was too dark, appearing almost black. In the shot on the right, the film was pre-fogged with a green separation filter (filter factor of four). This brought out the green of the bottle without affecting the red of the other bottles. The difference is subtle but effective.

A color film that can be manipulated, either in the home darkroom or by a custom lab, is Ektachrome. The luminance range of Ektachrome film can be expanded by about one zone by underexposing one stop and having the film pushed one stop in the processing to increase the highlight contrast. Ektachrome can also be compacted by one zone by overexposing by one stop and underdeveloping by one stop. (Information on Ektachrome manipulation is available from Eastman Kodak.) Pre-fogging Ektachrome to a four-stop underexposure effectively expands the luminance range by one zone.

Some color contrast control can be achieved by using color-correcting (CC) filters. Black-and-white filters are too intense for color photography, so color photographers use color-correcting filters in densities from .05 (5 percent) to .50 (50 percent). These filters are available in the primary colors (red, green, and blue) and the secondary colors (cyan, magenta, and yellow).

To understand the subject of contrast control with the use of color-correcting filters, let's assume that a lemon in a still-life setup appears relatively darker than the rest of the scene in the final transparency. To correct the problem, view the transparency through a series of yellow CC filters held close to your eye. Decide which density seems to correct the problem, reshoot using that filter, and examine the corrected transparency. You may find that the yellow you've chosen adds too much yellow to the overall scene and darkens the blues too much. A certain amount of trial and error is needed when using CC filters. As a rule, a .10 or .20 filter is sufficient. Never judge color by laying the filter directly on the transparency, as the visual density of the filter will seem to create a greater correction in the highlights than will actually occur.

Sometimes the primary subject in the scene appears to be slightly off color; for example, neutral gray appears to have a greenish tinge. View the transparency through a series of CC filters of the complementary color until the problem appears to be corrected. Reshoot the scene with the chosen filters and look at the new transparency carefully. The differences between colors are sometimes subtle, as with cyan and green. In the case of the greenish gray, magenta filtration corrects the color only if the greenish cast is caused by true green; if the cast is caused by cyan, magenta filtration will make the gray appear bluish.

Contrast can be reduced in color work by substituting duplicating film for normal camera film. Duplicating films are low-contrast copy films designed to compensate for the inherent buildup of contrast found when an original is copied. In a sense, it is like having a grade 1 color film.

For exposures of less than 1 second, use Ektachrome Duplicating Film #6121, available in sheet-film sizes, or Ektachrome Duplicating Film SO 366, available in 35mm rolls. For exposures of more than 1 second, use Ektachrome Duplicating Film #5071, available in 35mm sizes. Both films have an ASA of between 12 and 20. Since these films are not designed for in-camera use, the manufacturer does not balance them for specific light sources. Extensive testing by the user is necessary to find the correct filtration. Shoot a range of exposures of a gray card, process them, correct the color, and try again. Results can vary considerably from batch to batch with these films, so be sure you have enough of a particular emulsion number.

In flatly lit situations, Eastman Vericolor II, Type L is a good film to use. It is a high-contrast color negative film designed for commercial photographers. Eastman Vericolor II, Type S is a lower-contrast color negative film designed primarily for portrait use. It is well suited for contrasty situations.

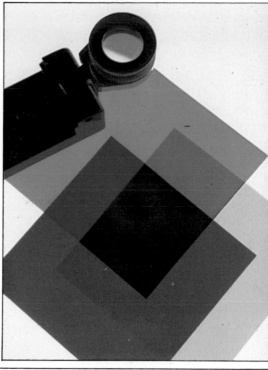

The primary color filters are red, green, and blue. Where any two overlap, black is produced.

The secondary color filters are yellow, magenta, and cyan. Where any two overlap, a primary color is produced; where all three overlap, black is produced.

RECIPROCITY FAILURE

An important factor to consider in determining exposure is reciprocity failure. The law of reciprocity states that different combinations of aperture and shutter speeds will give the same exposure. In other words, an exposure of 1 second at $f/8$ should be equal to an exposure of 8 seconds at $f/22$. In reality, however, the law of reciprocity fails when exposures are longer than about 1 second for either black-and-white film or daylight color film. With either type of film, exposures of approximately 1/1000 second also show reciprocity failure. The effect is insufficient exposure. A simple formula for calculating the approximate exposure correction for reciprocity failure in most black and white and daylight color films is: Multiply the indicated exposure time by its square root.

With black-and-white film, reciprocity failure is fairly easy to correct: either open the aperture wider or increase the exposure time. With color film, the problem is more complex, because each emulsion layer of the film has a different threshold of reciprocity failure, leading to color shifts. Consequently, reciprocity failure in color film is corrected by a combination of increased exposure and color-correcting filters.

For exact information on how to correct a particular film, refer to data provided by the manufacturer.

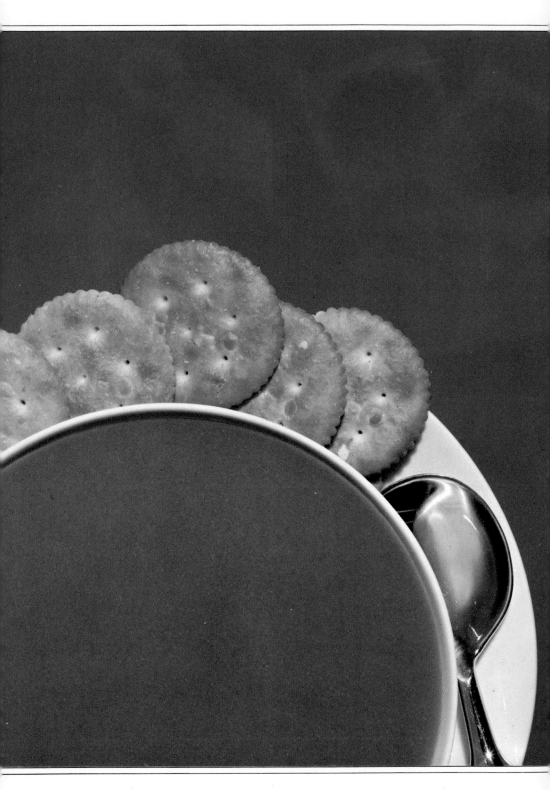

5

Design and Color

Basic design falls into three categories: literary, realistic, and pure.

Literary design deals with symbols generally found in Western or Oriental literature and culture, such as the dove or olive branch to stand for peace, the heart for love, or the signs of the zodiac for the qualities they represent. These are useful in visual design primarily as symbolic props to reinforce the idea or emotion you wish to express, and not as pure design elements.

Realistic design demands rational relationships to be understood. In Western culture the relationship of a tennis racket and ball, of a cup and saucer, of a pencil and paper, or of ice cream and cone are universally understood. They are examples of intellectual design because their relationship to each other makes sense because of their function, not their form. Someone who has never heard of tennis, for example, would see only shapes and not any of the symbolic meanings a racket and ball can have.

Pure design is the third dimension of visual design—basic, instinctual, and totally emotional. It is understood everywhere because it is fundamental design, utilizing the basic elements of design: line, direction, shape, measure, texture, value, and color. These elements are the alphabet blocks of design.

Design is man-made order. Its structure includes such qualities as repetition, harmony, contrast or discord, gradation, proportion, placement, variety, interval,

dominance and, of greatest importance, unity. Without unity and a dominant element, a design disintegrates. Thus, to create a successful design, the photographer must take the basic alphabet and, as in writing, form words, sentences, and paragraphs that have an organized field of visual meaning.

Repetition is the pairing or combining of like forms, such as line, direction, shape, measure, value, or color. Repetition in design is the most monotonous form and is usually best used as background interest.

Harmony is a sort of middle area combining similar design elements, and falls between the monotony of repetition and the cacophony of total discord. How close to either extreme is determined by the photographer.

Contrast or discord is the combining of dissimilar elements. Discord is necessary to avoid monotony. Contrast intensifies the differences between elements; a marble feels smoother when contrasted with burlap, yellow appears brighter when contrasted with dark blue.

If two units share no similar elements, they are discordant or have maximum contrast. If they share one element in common, they are harmonious. If they share two or more elements in common, they are more harmonious. If they share all elements, they can often appear to be repetitious.

Children and primitives often prefer discordant design, particularly in the area

To intensify the texture and color of the crackers, they were contrasted to the smooth texture of the soup and the untextured background. The repetition of round shapes between the bowl and the crackers ties the composition together.

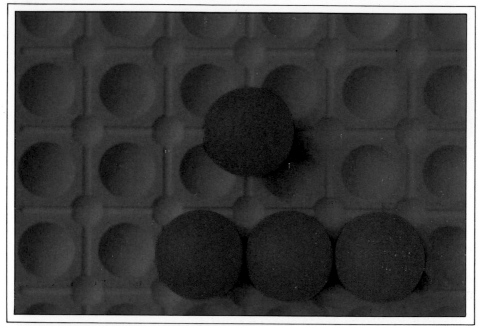

Great harmony is exhibited in this close grouping. If the single ball were positioned directly over the center ball, the result would be symmetry.

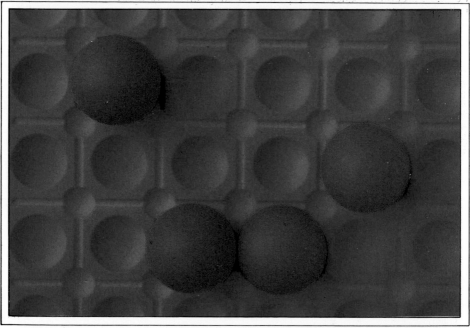

In this arrangement of the same elements, slight discordance of position is seen. The upper left-hand ball is the most discordant element; the lower left-hand ball acts as a harmonizing element.

The greatest discord is shown in this grouping. By removing the lower left-hand ball, greater tension is created.

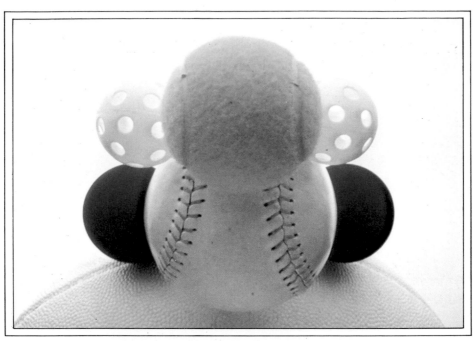

In this picture, the design is symmetrical. Both the shapes and colors of the left-hand side mirror those of the right-hand side. It's rather dull.

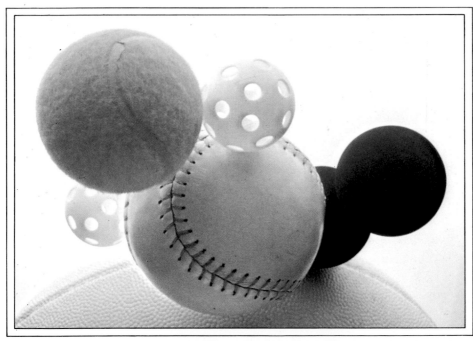

Here the same elements are rearranged in a more dynamic fashion to make a basically harmonious composition. However, the larger yellow ball adds a discordant note.

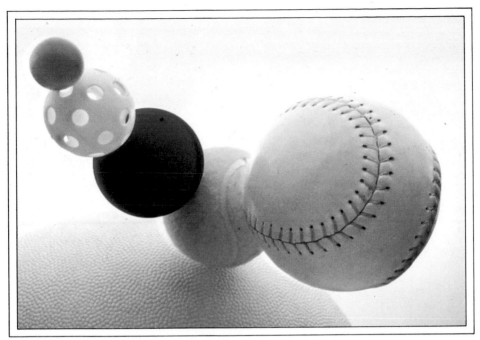

Repetitious harmony is shown in this picture. Each succeeding ball in the composition is slightly larger than the previous one. The effect is to lead the eye from left to right. Again, this composition is rather monotonous.

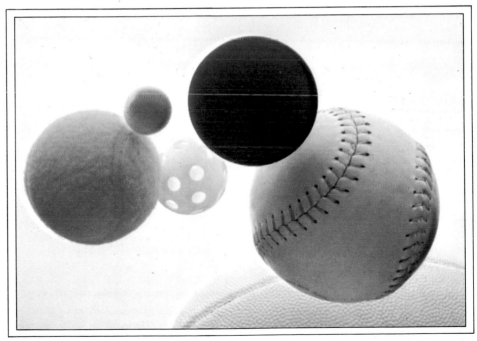

The greatest interval, variety, and unity are shown in this picture, a good illustration of harmonic discord. The placement of the different sized balls sets up an uneven variety of interval, while the circular shape of the balls acts as a unifying element.

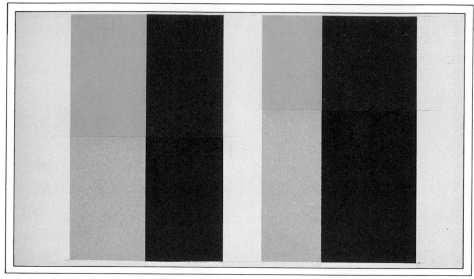

Subdivided rectangles. The rectangle on the left is evenly divided into four segments of the same size and shape; it is rather dull and monotonous. The rectangle on the right is divided on the diagonal. The lower-right and upper-left rectangles mirror the overall rectangle in shape, using the Golden Mean proportion.

of color and shape. Unfortunately, in too many cases, adults have had their design and color tastes refined to such a conservative degree that what they appreciate borders on the dull.

Gradation in either line, direction, size, measure, value, or color is a transitory element. It implies change or movement in the photograph.

Proportion. Many designers feel that the Golden Mean (1:1.618) is the most beautiful proportion. Others prefer a rectangle based on the square root of two (1:1.414). The proportion of a 35mm slide is midway between these two.

Subdividing a rectangle is another problem in proportion. Look at the two rectangles on page 60. Which division of the rectangles is more interesting? The one on the left is divided into four equally sized rectangles; it's rather monotonous. The division of the rectangle on the right was accomplished by drawing a diagonal

and forming different sizes, shapes, and intervals. It exhibits variety and interest.

The diagonal line is equally useful in determining the placement of elements in the composition.

The center and edges are areas of strong attraction. The spaces between free themselves from this attraction. The degree of space between these two powerful areas determine the amount of tension created. Additionally, the position of a form strengthens the field of force surrounding it. A central vertical line strengthens the central vertical and the top and bottom edges; it weakens the sides.

Interval. Even intervals of line, direction, value, or color are repetitious; slightly uneven intervals are harmonious; vastly uneven intervals of these elements are discordant. Unequal intervals produce a variety of contrasts, thereby adding interest to the picture.

Variety, as the old saying goes, is the

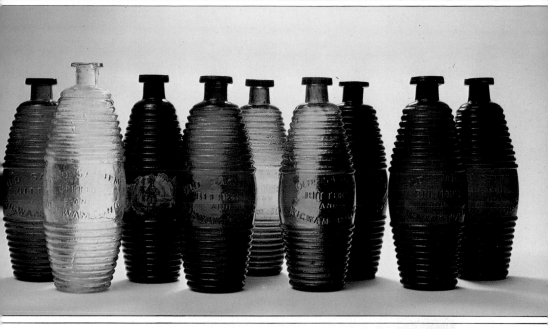

The interest in this picture comes from the uneven intervals of color and value. Had the shot been arranged with the tones diminishing from light on the left to dark on the right, it would have been dull indeed.

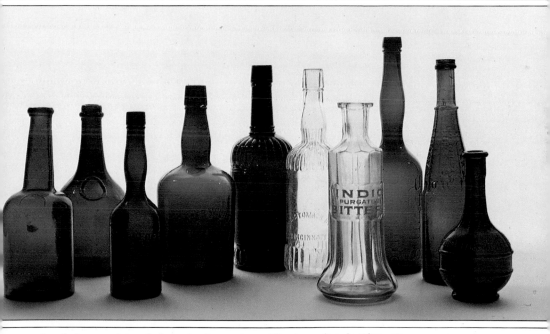

An obvious variety of shape is shown here. The two clear bottles set up an uneven interval, but the fact that they are all bitters bottles acts as a unifying element.

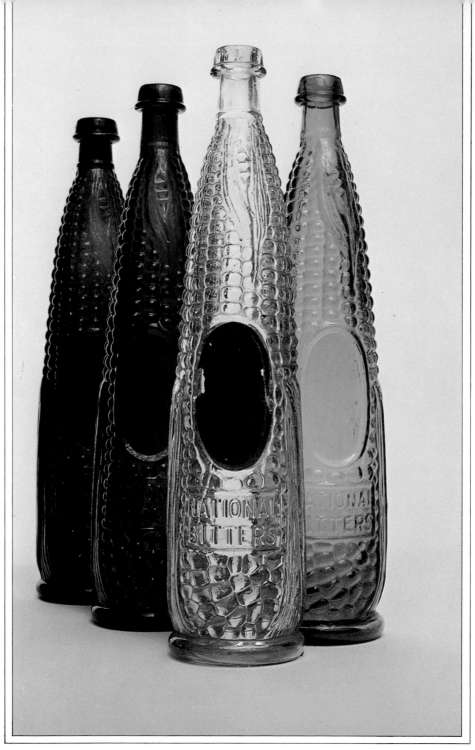

The clear bottle is the dominant element is this composition because of its color (or lack thereof) and larger apparent size. The repetition of shape among the other bottles reinforces the dominance. Variety and interval are established by the different sizes, colors, and values of the bottles.

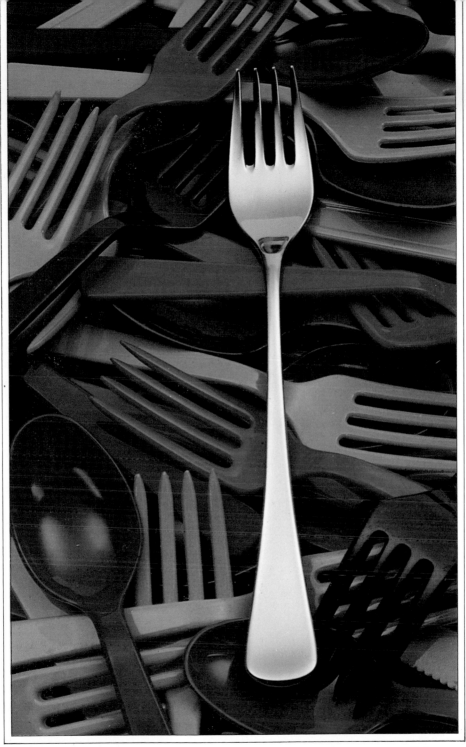

The multi-colored forks and spoons in the background of this shot act as a unifying element. Their variety of color and value add to the excitement of the composition. The silver fork is a dominant element.

spice of life. Both variety and interval add interest. The more variety of size, shape, value, color, placement, and interval, the more interesting the design becomes.

Dominance is a unifying element. In visual design, some element of the composition must dominate. (Advertising still-life photos, where each of the manufacturer's products must be equally represented, are classic examples of design schizophrenia.) Dominance can be produced by repetition of line, shape direction, value, or color. It can be produced by increased size or intensity of value or color.

Unity is the mortar that binds the building blocks of design into a complete, cohesive composition. Any orderly arrangement where the elements of design are subordinated to a distinct plan will produce unity. Repetition is one of the most primitive and most modern and simplest unifying elements. Exact repetition is not necessary; modifying the repetition by pairing a small square with a larger one or a lighter color with a darker version of the same color creates harmonic repetition.

Static elements of unity are generally geometric shapes, rocks, mountains, and man-made items. Most symmetrical compositions exhibit static unity.

Elements of dynamic unity are generally plants or animals. Plants are examples of passive dynamic unity; animals examples of active dynamic unity. Dynamic designs are usually based on such forms as the spiral, or the rise and fall of an ocean wave. A composition is not restricted to only one unifying agent but may incorporate all.

A low major key shot, this picture of old-fashioned tobacco tools is a good example of contrast and repetition in design. The textures show a lot of contrast between rough and smooth, and there is both contrast and repetition of line. All serve to unify the composition.

OPTICS AND DESIGN

When should the still-life photographer use a wide-angle or a telephoto lens? The wide-angle lens is best used when exaggerated perspective is required or when a small foreground object must be dominant when placed in front of a large background. Conversely, a small foreground object that must dominate in front of a small background can be enhanced by using a telephoto lens. A wide-angle lens generally stretches a scene, creating the illusion of great space. A telephoto lens compacts the scene, foreshortening objects and making them appear flatter or bulkier. Interestingly, when a cube is photographed with a long telephoto lens, the more distant plane of the cube will appear to be larger than the near plane. This is an optical illusion and has been used very effectively by many modern painters of the twentieth century.

The discordant shapes of this classic still life are unified by the harmony of the colors, the framing effect of the tray, and the related nature of the bread, cheese, and fruits.

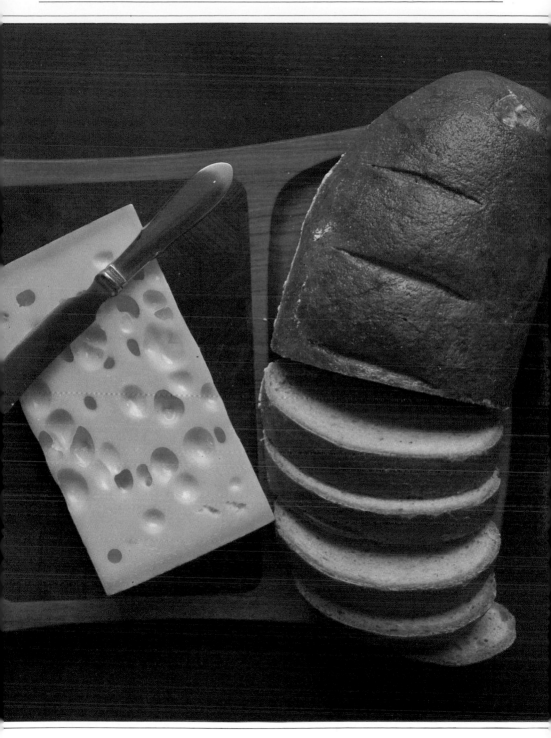

COLOR AND VALUE

If you, unknowing, are able to create masterpieces in color, then unknowledge is your way. But if you are unable to create masterpieces in color out of your unknowledge, then you ought to look for knowledge.
—Johannes Itten, *The Elements of Color*

Color and value are intrinsically tied together. Value by itself is black-and-white photography, but value is equally as important in color. In this section we'll look at examples of value and color keys and several color chords based on the theoretically ideal subdivision of a rectangle. These chords show the ideal proportions of color and value to achieve harmonious design. They are shown only as guides, not inviolable rules.

Color terminology, particularly in fashion and interior decoration, is often ambiguous. What color exactly is navy blue? Colors in general can be defined by three aspects: their hue, value, and chroma.

Hue is the name of the color. Red, yellow, green-blue, and purple are the principal hues. Yellow-red, green-yellow, blue-green, purple-blue, and red-purple are the intermediate hues. In a color wheel, the colors are arranged in a circle. Diametrically opposed colors on the color wheels are complementary to each other.

Chroma refers to the intensity or purity of the hue. Vivid colors have a strong chroma or saturation; pastel colors have weak or desaturated chroma.

Value refers to the luminance level of gray approximated by the color.

The color or value key of a photograph determines its mood. High-key pictures, with all of the elements in the photograph of light color or value, are generally happier, more spacious, and feminine in mood. Low-key pictures, with a predominance of dark tones and color, are masculine, somber, and more dramatic.

The contrast of white to black on a 10-step scale is the maximum contrast possible, with middle gray, value 5, as the fulcrum. Any combination that features white to black is a major key. A composition with values or colors ranging from either black or white to the middle value is considered a minor key. A major key extends to a full 10-step value range. A minor key covers only five value steps. Where the dominant or largest area of the composition falls on the value scale determines the basic key: it will be high at values 8 or 9 intermediate high at values 6 or 7, intermediate at values 4½ to 6½, intermediate low at values 3 or 4 and low at values 1 or 2.

The chart below gives examples of each value key on a ten-step white-to-black scale.

Key	Dominant	Secondary	Smallest
High Minor	8	9	5
High Major	8	9	1
Intermediate High Minor	6	7	9
Intermediate High Major	6	9	2
Intermediate Minor	5	3	8
Intermediate Major	5	8	1
Intermediate Low Minor	4	3	1
Intermediate Low Major	4	2	9
Low Minor	2	1	5
Low Major	2	1	9

Color keys follow the same concept, substituting colors for shades of gray.

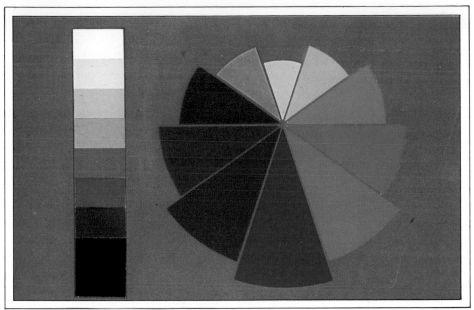

The black-and-white scale on the left in this illustration shows a ten-step gradation. Middle gray is the fifth step. The color wheel shows proportionate colors for harmony.

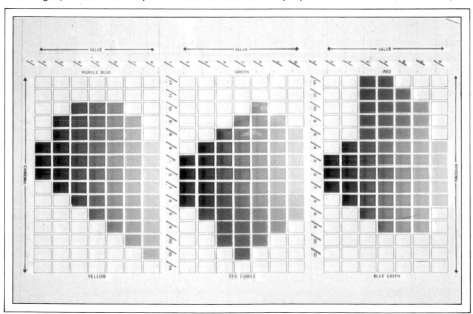

The Munsell color classification system is organized according to the three dimensions of color: the hue (the name of the color), the value (its lightness), and the chroma (its saturation). The cross-section shown here indicates how the value is represented by a gray scale running vertically through the center. Each hue gains saturation as it moves from the center to the edge of the shape. By numbering each gradation, the Munsell system allows precise definition and matching of colors.

COLOR AND VALUE KEYS

Color and value keys are shown in the illustration on page 69, with the approximate proportion of each color or value. Again, these are not unbending laws, only guides.

Color harmony. There are three basic forms of color harmony: monochromatic, lateral, and complementary. These three can be further subdivided into monochromatic with complementary accents, lateral with complementary accents, and complementary with lateral accents.

Monochromatic harmony is a design utilizing only one hue but with greatly varied values and chroma.

Lateral harmony could combine yellow with yellow-green and green or yellow with yellow-green and yellow-red. Lateral complementary harmony might include yellow, yellow-green, and yellow-red with accents of purple-blue.

Complementary harmony could pair red with blue-green or yellow with purple-blue. Complementary lateral harmony could be a combination of yellow and purple-blue with accents of either yellow-green, green, yellow-red, or red. The variations of color harmony are nearly infinite.

Color chords. The concept of color and value chords was originally developed by Maitland Graves as a guide for determining harmonious color and value rhythm. Rhythm is defined as measured, proportioned intervals. Equal intervals make monotonous rhythm; unequal intervals create interesting rhythm. Color chords are planned to create the greatest possible variety of six unequal color intervals using four colors. The intervals are determined by percentages of the area of each color or value, derived from the Golden Mean proportion. These proportions are 45%, 28%, 17%, and 10%. Using different proportions will change the areas correspondingly.

There are eight basic hue plans, 10 basic value plans, and 16 basic chroma plans, allowing for either dark dominant elements against a light background or light dominant elements against dark backgrounds. The two color chords illustrated on page 60 show rectangles divided into their most harmonious proportions, one with a major and one with a minor color key.

To determine a color chord, first determine the hue plan. Generally, the hue plan assumes the largest area of the composition to be the dominant element. A predetermined color can be placed at any of the four positions and the chord calculated from that position. Next, determine the value plan, whether weak, moderate, or strong, and then select the chroma plan on the same basis.

Religious adherence to color chords is not necessary. Experiment with these principles to broaden your knowledge of the innumerable color combinations available.

Symbolic color. An understanding of the psychological and symbolic associations of color is needed to plan composition intelligently. Warm colors, yellow, orange, and red, are positive, restless, or aggressive; cool colors, violet, blue, and green, are negative, tranquil, retiring. Psychological studies show that the colors in order of preference are: red, blue, violet, green, orange, and yellow. Red is most popular with women; blue is most popular with men. Pure color is preferred to shades or tints when used in small areas, but shades and tints are preferred over pure color when used in large areas. Color combinations are preferred in this order: contrasted; harmonious; monochromatic.

Colors have definite symbolism and psychological associations.

Yellow. Pleasant, bright, clear yellow is emblematic of the sun. It is a cheerful and gay color, and a sacred hue in the Orient. The darker, more neutralized yellows and greenish-yellows are the most unpopular

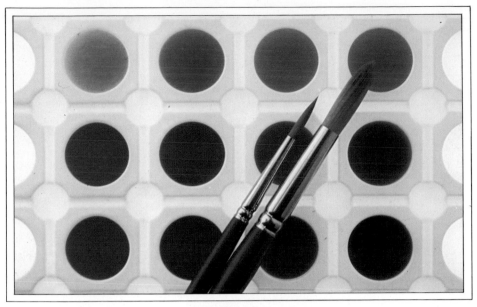

The palette in this photo has been designed to illustrate monochromatic harmony by using the same hue, red. The value and chroma extend from the purest, to the palest, to the darkest.

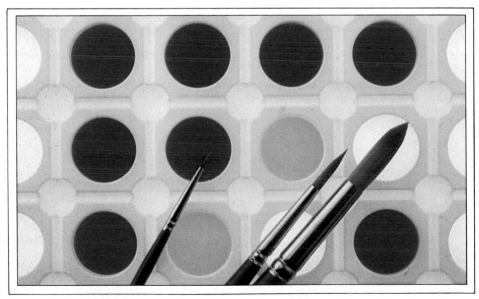

A formula for complementary color harmony is illustrated here. The palette shows two parts yellow to eight parts purple-blue.

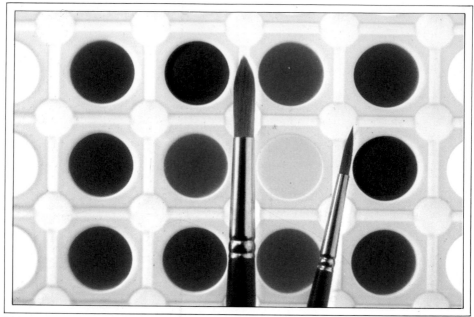

This major chord is made up of six parts purple-blue, two parts blue, three parts red-yellow, and one part yellow. It covers a full ten-step value range.

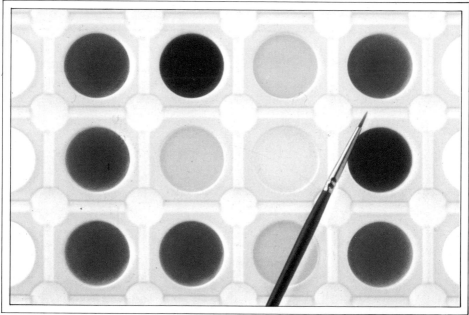

To make this minor chord, six parts of purple-blue, two parts purple, three parts blue-green and one part light purple were used. It covers a value range of about five steps.

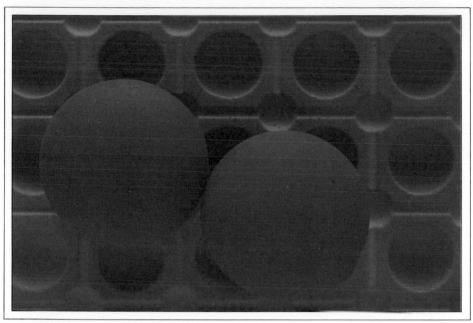

This blue palette is an example of monochromatic harmony. Including the highlights on the palette, the value scale covers only two steps, making this low minor key shot.

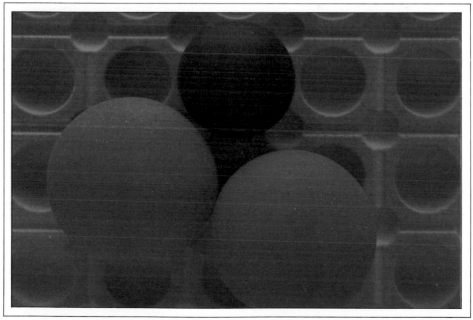

The addition of the black ball to this composition extends the value range another step. The shot retains its monochromatic harmony and remains in a low minor key.

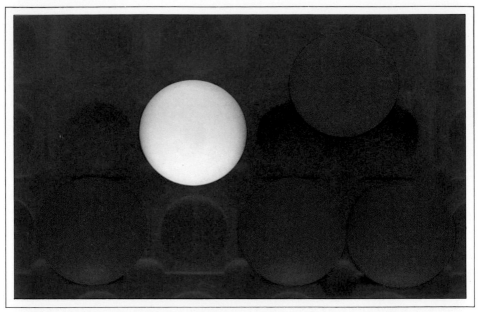

The red ball added to the palette here supplies discordant color to the intermediate key composition. The value range is now about five steps.

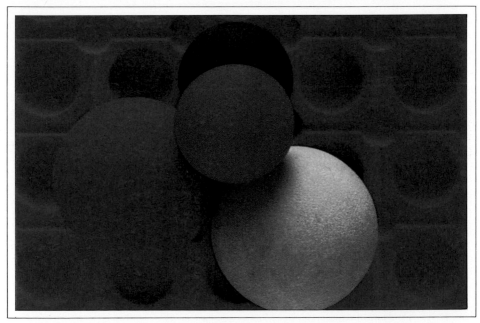

Blue, black, red, and flesh-colored balls against a dark blue palette are an example of a low intermediate key composition. The value range covers about seven steps. The flesh-colored ball complements the background color; the red ball adds a bit of discordant spice.

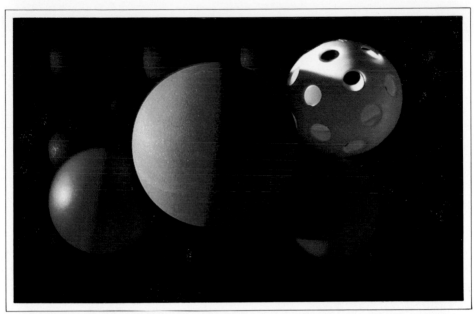

In this classic example of a low major key shot, two red, one blue, and one white ball are on a black background under very contrasty light. Although the value scale extends over its full range, the shot is still low-keyed because the dominant value is dark.

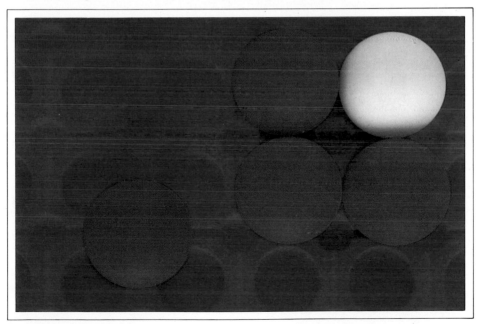

An intermediate low major key with color discordance is created by these balls on a dark blue background. The four red balls raise the overall key to between low and intermediate, and the one white ball contrasted against the background makes it a major key. Unity results from placing three red balls immediately adjacent to the white.

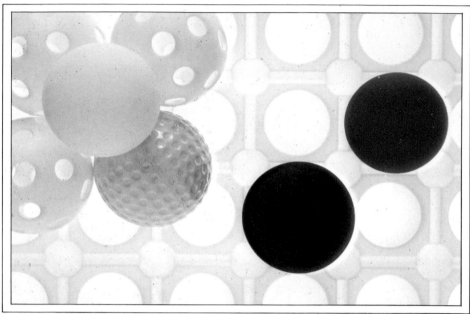

A full value scale is shown in this shot, ranging from white to black. The cluster of white balls balances the smaller mass of the red and black balls.

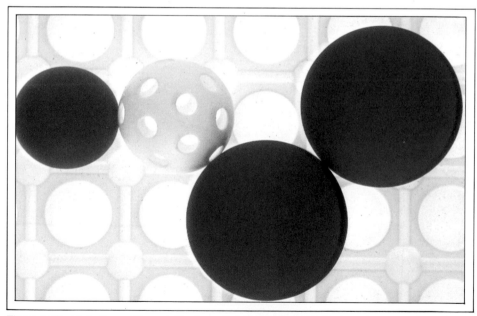

These balls against a white palette form an intermediate major key, because the values extend over a nine-step range. The white and blue areas occupy about the same amount of space, making this composition a little too balanced. The addition of the red ball saves it from being dull.

of colors. They are associated with sickness, indecency, cowardice, jealousy, envy, and treachery.

Red. Red has the strongest saturation and the greatest power of attraction. Red is the color most used in primitive and classical art. It often symbolizes primitive passions and emotions. Too much red causes eye fatigue, generating a desire for its complement, blue-green.

Violet. Violet is cool, negative, and retiring. It is similar to blue, but more melancholy.

Blue. Cool, serene, and tranquil, in Christianity blue symbolizes sincerity, hope, and peace. The Spanish and Venetian elite of the Renaissance affected blue or black costumes.

Green. Similar to blue, green is relatively neutral in its emotional effect as compared to other colors. In religion, green represents faith, immortality, and contemplation. It can also symbolize freshness, callow youth, and immaturity. The green olive branch is a symbol of peace; the green laurel wreath is a symbol of immortality.

White. White is positive and stimulating as compared to black or gray. It is luminous, airy, light, and delicate. White is associated with purity, chastity, innocence, and truth.

Middle gray. This color has qualities of both black and white. It has a mellow richness. Middle gray is the ideal background for most colors. Gray generally symbolizes sedate and sober old age.

Black. Subdued, depressing, solemn, and profound, in Western civilization black signifies sorrow, gloom, and death. Black by itself is somber, but when used as a background for color reinforces the color.

Simultaneous contrast. A strange phenomenon occurs when a bright or strong dominant color surrounds an area of neutral gray. The gray will appear to be tinged with the complement of the dominant color. To minimize this effect, add a five- or ten-percent filter of the same hue as the dominant color. To exaggerate this effect, filter with a complementary colored one. (The duotone color printing process depends on this simultaneous contrast to create the illusion of full-color printing while actually using only one color and black.)

Spatial color. Some colors psychologically advance and others recede. In nature, light blue such as the sky is highly recessive; darker blues such as water are less recessive, and reds and yellow seem to advance. The reason for this is that the shorter wavelengths of light (blue) are in focus when the lens of the eye is closer to the retina, while the longer wavelengths of light (red) are in focus when the lens is farther from the retina. Knowledge of these phenomena is of particular value to the photographer working with miniature sets that are designed to mirror nature.

When working with pigments or abstract designs and a black background, yellow advances the most, red advances to a lesser degree, green is practically neutral, and blue recedes. But, when the background is white, the spatial effect is reversed. This is due primarily to the values involved. With a black background, the order of densities would be black, dark blue, medium green, medium to bright red, and bright yellow, a rational gradation. With a white background, bright yellow is closer in value to the white. Thus, the progression proceeds through the red and green and ends with the darker blue; a logical gradation.

Irradiation of color or value is an optical illusion that causes an area of white or intense color on a dark background to appear larger than it really is. Conversely, dark colors or values against white appear smaller than they really are. The illustrations on page 78 show a black or dark-colored circle on a white background and a white or brightly colored circle on a black background. All the circles are actually the same size.

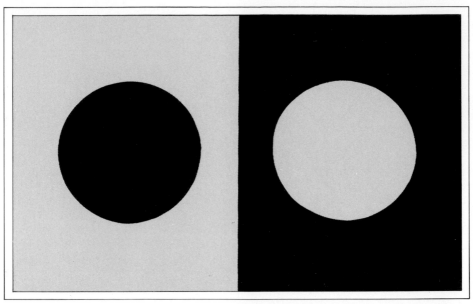

An optical illusion causes the white circle against a black background to appear larger than the black circle against a white background.

The same optical illusion is at work here, making the red circle against the black background appear larger than the black circle against the red background. All the circles are really the same size.

A disturbing vibration pattern is set up when intense reds and blues are placed together. The irradiation effect can be avoided by separating the two colors with a black or white line.

Another form of irradiation occurs when two equally sized patches of intense colors such as red and blue are placed together. As shown in the illustration on page 79, the apparent effect of this juxtaposition is that the two colors appear to vibrate. The effect is purely physical, because the eye is forced to focus first on the blue, then on the red, and then back to the blue. To prevent this irradiation, separate the two colors, perhaps with a black or white line. This phenomenon does not occur with any other color combinations.

DESIGNING A COMPOSITION

To design a good composition you must plan. A good procedure is: (1) Determine what you wish to say. (2) Determine how you wish to show your subject; as a realistic scene, as an abstract study, or with surrealism. (3) Based on 1 and 2, determine what props are necessary. (4) Block the composition. It is best to forget details at this point as you are only interested in the overall shape of the picture at this stage. (5) Determine the mood and key of the composition. (6) Plan the lighting based on the key chosen. Low keys may require moody, dramatic lighting. High keys will tend to be almost shadowless. (7) Plan the color and value chords to fit the key of the photograph, whether strong, moderate, or weak. (8) Determine the focal length of lens to be used to best achieve the effect desired.

As you become more experienced, steps 4 through 8 will be done on camera, and you will be on the way to mastering the craft of still-life photography. The pictures on the following pages will give you an idea of how creative you can be.

Formal design in a low major key was used for this shot of memorabilia of the composer Louis Moreau Gottschalk. The exaggeration of perspective caused by the use of a very wide-angle lens adds a dynamic quality.

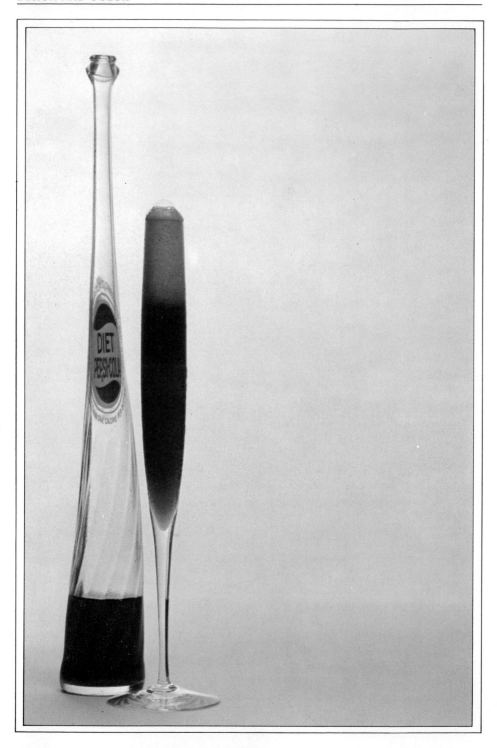

The idea above is to show the need for eyeglasses. The key is high minor; the soft-focus lens expresses the mood and also graphically shows why eyeglasses are necessary.

The thinness supposedly achieved by drinking diet cola is shown in the shot at left. The diet cola bottle was purchased at a novelty shop; the cola glass was a bud vase. The key is high minor; space was left at the right for ad copy.

This abstract composition (above) of an antique restaurant menu board, a duck decoy and an orange symbolizes the dish duck à l'orange. It is an intermediate, high minor key. The menu board dominates. The decoy, a strong contrast of shape and value, separates the menu board from the background; the orange adds a bit of strong, discordant color. The halated effect created by the soft-focus lens acts as a unifying element.

At left is a low major key shot using traditional, formal composition. The color scheme is traditional, with an Old Master quality. The paper streamers add a discordant color to an otherwise mundane shot.

An opinion about airline cooking is expressed above. The key is high intermediate; the airplane sandwich is the dominant element. This is a simple composition that is saved only by a rather good idea.

The shot at right makes an anti-smoking statement and is surrealistic in form. The key is low major to convey a feeling of doom. The crudely stained wooden mannequin hand suggests dirt and illness. The second hand and cigarette create design repetition; the white cigarettes become a dominant, discordant accent.

To illustrate an article on slipshod record manufacture, this shot was created. The wooden hand was used to give a surreal touch. The checkered square symbolizing the turntable is also the most contrasty element in the composition and draws the eye to the melted records. The colors are discordant but similar in value. The key is intermediate major, but the overall effect is that of intermediate only.

This picture of vodka, empty glasses, and fruits shows contrast of shapes, minimal overall color, accents of very strong color, and extreme contrast of black and white.

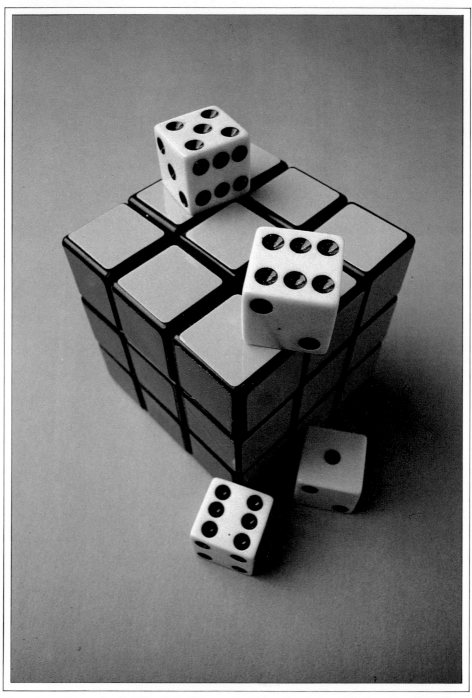

These two views of a Rubik's Cube™ were shot from the same camera angle. This one, taken with a 20mm lens on a 35mm camera, shows extreme keystoning of perspective.

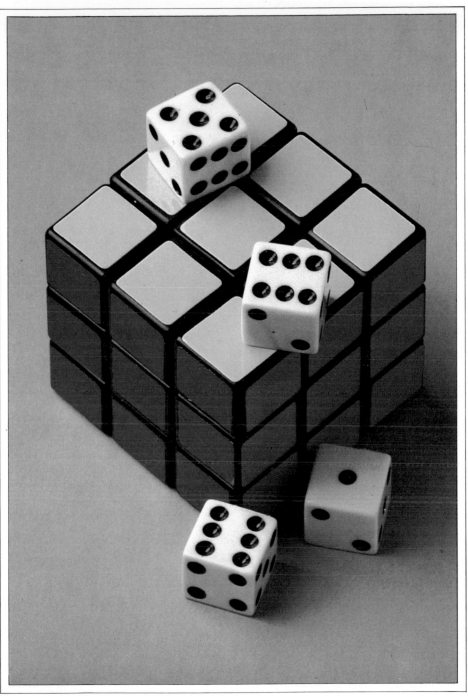

This view, taken with a 200mm lens on a 35mm camera, shows the optical illusion of reverse keystoning.

6

Still Lifes
Outdoors

The difference between outdoor still-life photographs and studio still-life photographs is the difference between the immediacy of a watercolor painting and the reworkability of an oil painting.

The two basic lighting problems encountered in outdoor photography are excessive contrast and, in color photography, incorrect color balance. Solving these problems and effectively lighting the outdoor still life requires a subtle eye, lots of white cards or reflectors, scrims, supplementary flash, and ingenuity.

CONTRAST OUTDOORS

When shooting in contrasty, direct sunlight, which can have a lighting ratio of as much as 7:1, the luminance range can be 1792:1 (256 × 7) from the darkest to the lightest gray. This works out to six f-stops of excessive contrast to try to control. When confronted with such a contrasty lighting situation, the best solution is to move the subject to a location where the lighting conditions are more favorable to the photographer. Unfortunately, that is not always possible.

Basically, there are two ways to lower the contrast of outdoor lighting, or, for that matter, any lighting. One is to reduce the luminance or intensity of the highlights, and the other is to increase the luminance or intensity of the shadows. The following are some suggestions for reducing lighting contrast.

Scrims. A scrim is usually a piece of cheesecloth, matte plastic sheeting, or tracing paper, a frosted shower curtain, or, in an emergency, a white bed sheet placed between the subject and the sun. Scrims are used primarily to reduce the luminance level of the highlights. Their use can reduce a 7:1 lighting ratio to as little as 3½:1. The bigger the scrim in relation to the size of the subject, the better. To determine the light absorption of the scrim material, read the basic light with and without the scrim. The difference is the absorption factor.

A *gobo* is also used to control the placement and intensity of light. It consists of a rectangular or otherwise-shaped piece of black cardboard or plywood mounted on a stand. It is used to block part of the light.

Time of day. An old photographer's rule is to shoot before 10 A.M. or after 3:30 P.M. or during the winter months. Midday overhead sunlight is a killer. There is virtually no modeling from overhead sunlight, and the shadows are practically straight down. As to winter shooting, many clients prefer to have annual-report photographs taken during the winter months, because the angle of the sun is low on the horizon throughout the day, enabling very expensive per diem photographers to shoot from sunrise to sunset.

Reflectors. Use white cards or foil reflectors to raise the luminance level of the

Sometimes the contrasty light of overhead sun can produce a good outdoors still life. In this shot, no attempt was made to modify the light.

An overcast sky has the same effect outdoors as a scrim indoors—the light is even and diffused.

Five minutes after this shot was taken, it poured rain. Again, an overcast sky can provide beautiful light.

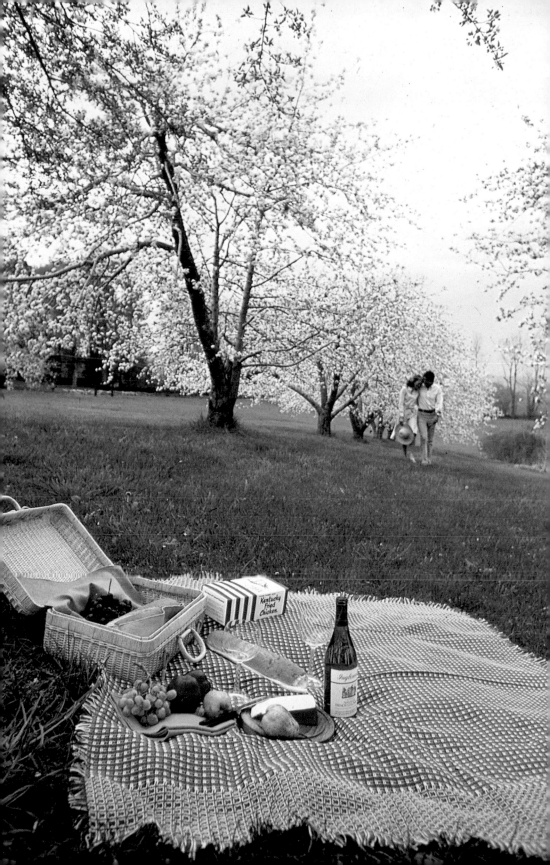

This shot was taken on a slightly foggy day in the late afternoon. The sun was nearly on the horizon and to the right of the camera.

Early afternoon is one of the best times for contrasty outdoors light. This shot was taken on a brilliant, cloudless summer day. The sun was to the left and behind the camera; a reflector leaning against the tripod was used to get the metallic lighting on the label of the bottle.

The light of a setting sun along the Hudson River was used to create this romantic shot. The wine glass was set up on the pan head of a tripod positioned to capture the castle's reflection. The highlights on the glass came only from the low angle of the sun.

shadows. A white card will give less fill than a foil reflector, but with softer, more modulated shadows. Remember, as with scrims, that a reflector larger in relation to the subject will give greater modeling.

Silver foil reflectors. Silver foil reflectors project a greater amount of light than white cards, although the quality of the light is much harsher and of a more directional nature. Foil reflectors are better used when you have to redirect light over a fairly long distance. You can soften this mirrorlike projection to a slight degree by crumpling the foil. On larger sets more than one reflector may be needed. At movie locations it is not unusual to see a set surrounded by 4-foot-square, crumpled foil reflectors with a lighting technician constantly monitoring their angle and direction so that the necessary 2:1 or 3:1 lighting ratio can be maintained. A foil space blanket, available from most sporting-goods stores, is a good emergency reflector source.

The clear light of a cold November afternoon was used for photographing these toy soldiers. Note the long shadows produced by shooting at 4:30 P.M. A wide-angle lens was used on a 35mm SLR camera.

Mirrors or ferrotype reflectors. A mirror is better used for redirecting light than as a fill source. When the sun is directly overhead and the subject is in shade, a mirror can effectively lower the apparent angle of the sun so that it will approximate late-afternoon lighting. Be warned, however, that when using this method, a scrim and a white reflector may be necessary, as mirrored sunlight is extremely contrasty. Ferrotype tins (really mirror-like chromium plates) offer two advantages over conventional mirrors. First, they are unbreakable. Second, since they are made of flexible metal, they can be bent in such a way as to either concentrate or disperse the sun's rays, thus giving the option of a spotlighted look or a soft look. A mirrored reflection of pure skylight gives a softer fill, although it is generally unacceptable when shooting color.

Flash fill. Flash fill is a rather harsh fill source, since it is basically a point source of light. This harshness can be reduced by directing the flash through a scrim. When using flash as a fill source, you must first determine your ambient daylight exposure and then position your flash to give you 1 *f*-stop less than normal flash exposure for a lighting ratio of 2:1. Use 1½ *f*-stops less than normal flash exposure for a lighting ratio of 3:1; use 2 *f*-stops less

A cheap mirror was placed on the sidewalk of this New York City street to reflect the autumn foliage. The props were placed directly on the mirror.

With natural light alone, the lighting ratio in this shot was about 16:1 because of the harsh direct sunlight.

To reduce the lighting ratio to about 4·1, an on-camera flash was used.

than normal flash exposure for a lighting ratio of 4:1. To determine the fill-in guide number for your flash, refer to the accompanying chart. If you want to do it the hard way, use the following formula:

1. Square the guide number of your flash.
2. a. For a 2:1 ratio, double the squared figure.
 b. For a 3:1 ratio, triple the squared figure.
 c. For a 4:1 ratio, quadruple the squared figure.
3. Determine the square root of Steps 2a, 2b, and 2c and you will have the fill-in flash guide numbers for your flash unit.

For example, with Kodachrome 64 (ASA 64) film, the guide number for your flash would be 80.

1. 80 squared = 6400.
2. a. 6400 double = 12800.
 b. 6400 tripled = 19200.
 c. 6400 quadrupled = 25600.

3. a. The square root of 12800 gives a flash-fill guide number of 113:14 for a lighting ratio of 2:1.
 b. The square root of 19200 gives a flash-fill guide number of 138:56 for a lighting ratio of 3:1.
 c. The square root of 25600 gives a flash-fill guide number of 160 for a lighting ratio of 4:1.

Flash Guide Numbers			
Basic guide number	2:1 Ratio	3:1 Ratio	4:1 Ratio
25	35	43	50
32	45	55	64
40	57	69	80
50	71	87	100
65	92	113	130
80	113	139	160
100	141	173	200
110	156	191	220
130	184	225	260

Once you have established the guide number for your fill-in flash, the procedure for calculating the flash distance (using Kodachrome 64 in bright sunlight with fill supplied by a flash with a basic guide number of 80) is to:

1. Calculate the ambient daylight exposure; in this case, 1/60 second at *f*/16.
2. Determine the lighting ratio required: 2:1, 3:1, or 4:1.
3. Determine the fill guide number: 2:1 = 113, 3:1 = 139, 4:1 = 160.
4. The flash distance is determined by dividing the guide number by the indicated aperture (*f*/16). Therefore, 2:1 = 113/16 = 7.06 feet; 3:1 = 139/16 = 8.68 feet; 4:1 = 160/16 = 10 feet.

Remember when using fill-in flash with a camera with a focal-plane shutter to follow the manufacturer's shutter-speed recommendations. Otherwise, you may have a picture with flash fill on only half of the frame. Use a flash-synchronization extension cord to facilitate placing the flash nearer to or farther from the subject.

Some of today's Thyristor-type automatic flash units are available with variable-output accessories. When using these variable-output accessories, the fill procedure is greatly simplified.

1. Determine the ambient daylight exposure. Kodachrome 64 in bright sunlight should be 1/60 second of *f*/16.
2. The guide number is 80, as explained earlier.
3. Divide the guide number by the indicated aperture: 80/16 = 5 feet.
4. Place the flash 5 feet from the subject.
5. To get a 2:1 ratio, adjust the varia-

Without a flash, this shot was taken at *f*/5.6.

By using flash as the main light, an aperture of *f*/16 could be used. Note the greatly increased depth of field.

ble output to give you ½ power. To get a 3:1 ratio, adjust the variable output to give you ⅓ power. To get a 4:1 ratio, adjust the variable output to give you ¼ power.

For critical work, any variable output accessory should be checked for accuracy, preferably with a strobe meter.

Flash as a main source outdoors. There are times when the contrast of ambient daylight is too low or flat for proper tone rendering. An example of this would be a totally overcast sky or shooting in deeply shadowed areas. You might then consider using the flash as a main source of light with ambient daylight as the fill. The procedure when using Kodachrome 64 film and a flash unit with a guide number of 80 is:

1. Determine the ambient daylight exposure; for example, 1/60 second at *f*/5.6.
2. Determine the lighting ratio needed; 2:1, 3:1, or 4:1.
3. A 2:1 ratio would indicate that the ambient fill should be 1 *f*-stop less than the main light. Therefore, the basic exposure should be 1/60 second at *f*/8. A 3:1 ratio indicates that the ambient fill should be 1½ *f*-stops less than the main light. The basic exposure should then be 1/60 second at *f*/9.5. A 4:1 ratio indicates an ambient fill of 2 *f*-stops less exposure, or 1/60 second at *f*/11.
4. Determine the flash distance in the usual way: guide number ÷ indicated aperture = flash distance. Therefore:

 2:1 ratio = 80/8 = 10 feet, and the setting is 1/60, second at *f*/8.
 3:1 ratio = 80/9.5 = 8.42 feet, and the setting is 1/60 second at *f*/9.5.
 4:1 ratio = 80/11 = 7.27 feet and the setting is 1/60 second at *f*/11.

For consistent results, prepare charts for flash fill and flash as a main light, calibrate to your own equipment, and keep the charts in your photo notebook.

COLOR AND COLOR CONTROL OF OUTDOOR LIGHTING

When shooting color outdoors, you are not only faced with the problem of controlling the contrast of light, but you also must be aware of the color temperature of this light and how to compensate for it.

First, let's define color temperature. Color temperature is the temperature to which a theoretical black body, or perfect radiator, must be heated from absolute zero (0 degrees Kelvin, or −273 degrees centigrade) for it to glow at a particular color. At 800 degrees Kelvin, a black body is red. As the temperature increases, the color of the black body changes: at 3,000 degrees Kelvin it becomes yellow; at 5,000 degrees Kelvin it becomes white; at 8,000 degrees Kelvin it becomes pale blue; at 60,000 degrees Kelvin it becomes a most intense brilliant blue. Color temperature is not a measure of how physically "hot" the light is. Rather, it is a convenient and accurate way of describing the quality of a light source. This in turn makes it a simpler matter to select the correct film and filters for a particular lighting situation.

Color films are balanced to give proper color rendition at various Kelvin temperatures. Daylight film is balanced for 5,500 degrees Kelvin, Type A color film is balanced for 3,450 degrees Kelvin, and Type B color film is balanced for 3,200 degrees Kelvin. Basically, this means that an 18-percent neutral gray card photographed under a light of 5,500 degrees Kelvin using daylight-balanced color film will be rendered a neutral gray. If this same gray card were photographed under light of 3,200 degrees Kelvin on daylight-balanced film, it would appear orange; if a color film balanced for 3,200 degrees

Light source	Temp. (° Kelvin)	Mired value
Clear blue sky	13,000–25,000° K	77–40
Hazy blue sky	9,000° K	111
Light overcast sky	6,500° K	154
Midday sun and sky	6,000° K	167
Average noonday sunlight	5,000° K	200
Sunrise and sunset	2,000–3,000° K	500–333
Late afternoon sun	4,300° K	233

(Refer to the Appendix for a more complete list of daylight color temperatures.)

Kelvin were used, the card would be rendered neutral gray.

Another numeric designation of color used in photography and physics is the mired valuation. The mired valuation system is particularly important in color photography in that it gives each lighting condition and each color filter a constant numeric valuation. To determine the mired valuation of the light, divide one million by the color temperature in degrees Kelvin. For example, daylight has an average color temperature of about 5,500 degrees Kelvin. Therefore, daylight color film has a mired valuation of $1,000,000 \div 5,500 = 181.81818$.

The actual color temperature of daylight, however, constantly changes. The chart above is a partial list of average color temperatures.

To compensate for the changing color temperatures of the light, the trick is to determine the mired shift, or the difference in mireds between the actual color temperature of the light and the color temperature for which the film is balanced. Once that is found, the correct filter can be used to either warm or cool the color temperature of the light.

The mired shift is found in this way:

1. Find the color temperature of the light source in mireds (divide one million by the color temperature in degrees Kelvin).
2. Find the color temperature of the film in mireds (again, divide one million by the color temperature in degrees Kelvin).

3. Subtract the mired value of the light source from the mired value of the film. The difference will give the mired value of the filter to use. If the result is a negative number, use a cooling filter; if the result is a positive number, use a warming filter (see the accompanying chart).

Warming Filters		Cooling Filters	
Filter	Mired shift	Filter	Mired shift
81	+9	82	−10
81A	+18	82A	−21
81B	+27	82B	−32
81C	+35	82C	−45
81D	+42	80D	−56
81EF	+52	80C	−81
85A	+108	80B	−112
85B	+131	80A	−131
85C	+81		

For example, a subject is in total shade lighted by clear blue sky with a color temperature of approximately 18,000 degrees Kelvin; the color film is balanced for 5,500 degrees Kelvin. To determine the filter to use, apply the mired shift formula:

$$\frac{1,000,000}{5,500} - \frac{1,000,000}{18,000}$$
$$= 181.818 - 55.55$$
$$= \text{mired shift of } +126.26$$

A minus shift must be neutralized by a filter with a plus factor. An 85B filter with a mired shift of +131 is the closest filter to the shift in this example.

Let's take another example. The color

The greenness of the light coming through the stained-glass window was compensated for by a .30 magenta filter.

temperature of the late afternoon sun is 4,300 degrees Kelvin and the film is balanced for 5,500 degrees Kelvin. Therefore use this formula:

$$\frac{1,000,000}{5,500} - \frac{1,000,000}{4,300}$$
$$= 181.818 - 232.558$$
$$= \text{mired shift of } -50.74$$

The filter chart indicates that an 82A filter (-21 mireds) plus an 82B filter (-32 mireds), or a total of -53 mireds, will give the closest color correction.

DETERMINING COLOR TEMPERATURE

A color meter calibrated to read three colors is the most accurate method of determining color temperature. Small, efficient, accurate three-color meters have only recently been available to the average photographer, so they are still comparatively expensive and in very short supply. Two-color meters have been available for years, but they are not particularly helpful. In most cases, charts of average color temperatures for particular outdoor conditions are very useful (see the Appendix).

ALTERNATE MEANS OF COLOR CONTROL

Filters. When there is excessive blue light from the sky, you can approximate the necessary correction by holding an appropriate 81- or 85-series filter to your eye; observe the shaded subject through the filter, and then quickly move the filter away from your eye and observe another subject in bright sunlight. When the filtered shade and the unfiltered sunlit scenes apparently match, you will have an approximate correction. Shoot your shaded scene with that filter.

Gold foil reflectors. Gold foil reflectors neutralize the blue from skylight. These

Magenta and red color-correcting filters were used to compensate for the greenish tinge from the skylight in this winery. This is also a good example of effective, rather than gimmicky, use of a fish-eye lens.

An 81A filter was used to compensate for the excessive blue caused by a bright blue sky.

reflectors should not be used to reflect direct sunlight unless you are seeking a special effect, as they will add too much yellow to the scene.

Colored cardboard reflectors. Colored cardboard reflectors can be used to neutralize excessive blue skylight or the green pall when shooting in areas surrounded by foliage. They are useful when the set is adjacent to any strongly colored surroundings. To neutralize the unwanted color, refer to a color wheel and choose a cardboard that is the complement of the color.

Roscoe gels. Roscoe Industries manufactures a complete line of colored gelatin filters in sheets and rolls designed to be placed over lights, hung in windows, or stretched over sets. For outdoor photogra-

phy, they can be used effectively in the same way as scrims.

USING THE SUN AS A PROP

The sun can be a very effective prop in your composition. It can add excitement to an otherwise dull situation. But you must remember that a very strong direct light shining into your lens can cause all matter of optical problems. When using the sun this way it is best to shoot with your lens at its widest aperture. Using a small aperture projects the image of the diaphragm onto each element of the lens and is in turn projected onto the film; the result is three, four, or five flare spots in the picture. A reflector is necessary when the sun is shining directly into the lens.

Clear glass against a dark background is one of the hardest subjects to light, since the curves of glasses and bottles act as lenses and mirror whatever is in front of them. This photograph was made with only one light—a 1,200-watt strobe placed to the right and slightly to the back of the set. Luminance in the bottle and wine glasses came from small, carefully shaped white card reflectors placed behind them.

7

Advanced
Lighting

Advanced lighting doesn't necessarily mean the use of more lights. Rather, advanced lighting is the refinement, or fine-tuning, of light: a room scene should look lived in; a sunlit scene in a studio should look natural. It is learning the techniques necessary to light specific subjects such as glassware, metallics, fabric, or wood. Advanced lighting requires a knowledge of ways to control light locally with diffusers, gobos, or scrims; to area light using many lights; to balance existing light, whether daylight, fluorescent, or candlelight, to the photographic emulsion: to know when and why to use polarizing filters and colored or shadowless light. This knowledge can then be applied so that you will be able to solve multiple subject lighting problems involving combinations of lighting, and so that you will be able to create or change the mood of your photograph at will by changing the lighting. Remember that the ultimate goal is no matter how complex the lighting actually is, it must *look* simple in the final photograph.

GLASSWARE

Glassware can be lighted with either bottom or back light. Bottom lighting allows the use of dark backgrounds and is the traditional way that glassware is shown in advertisements and catalogs. The glassware is placed on clear or opalized glass, and light is directed upwards onto it. The effect is a white edge surrounding the glassware, with softer milky highlights on the lower curves of the glass. Translucent or milky liquids give excellent results, and clear liquids give poor ones, when photographed against dark backgrounds with this lighting.

Silhouette or broad back lighting of glassware gives a glass with black edges. This black-edge effect can be reinforced by placing black reflectors on either side of and over the glass. This lighting is suitable for clear liquids; opaque liquids, however, need a front fill-in light. Silhouette back lighting with a frontal side light placed above the upper edge of the glass is ideal lighting for beer. The frontal side light is necessary to light the beer's head, and light's high position prevents specular highlights on the front of the glass. A variation of this lighting setup is to direct a spotlight onto the background above the glass and out of the picture area. This additional light adds interesting highlights and dimension to clear drinks. I've always called this martini-glass lighting, but it works equally well with drinks in most stemware glasses. This lighting renders a white background light gray, with the edge of the glass rimmed with both white and black lines.

Lighting bottles and wine glasses with a soft box or with a diffuser shaped like a window with crossed molding adds an interesting reflection to the surface of the bottle or glass. This lighting technique works equally well with light and dark backgrounds.

Directing a light at the lens with the bottle in between is an effective way of lighting liquid in a dark bottle. A small spotlight or slide projector is the best light source, although is may be necessary to cut a hole in the background so that the

To get a black edge to the glass on the left, the light was aimed high up on the background. For the white edge on the glass on the right, the light was aimed lower down on the background.

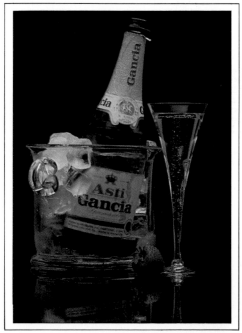

This shot had to be done quickly before the bubbles dissipated and the ice melted. To get the white rim lighting, basic direct back light was used with a reflector at a 45-degree angle above the lens and a second light for fill on the label. The base of the set is clear glass laid over black velvet to produce a reflection.

light can be hidden. I feel that when a bottle and glass of liquid are shown together, aesthetics dictate that the bottle should be less than full.

Clear liquid photographed against a dark background is helped by adding ice cubes or frost to the glass. Frost on a glass acts as a diffuser, adding overall luminance to the drink. A glass can be frosted by placing it in a freezer for 10 or 15 minutes, by spraying it with a freon glass chiller (available at department or houseware stores), or by spraying it with a mixture of glycerin and water in a perfume atomizer. The glycerin spray is not as realistic, but will last for days and is the best method when long-time exposures are needed.

Ice cubes add highlights to otherwise drab-looking drinks. I prefer real ice cubes, although I do use Lucite ice cubes (available at prop shops) for time exposures and for package design where the

position of the ice is important to the composition.

Direct light in addition to normal back lighting increases dimension when photographing textured glassware or glass molded in relief.

Lighting glass sculpture is a time-consuming challenge, as the varying surfaces of the figure refract light from the most unusual places.

METALLIC OBJECTS

Lighting metallic objects is not really difficult unless the object being photographed is a flat or spherical, highly polished metal such as silver or chromium. Metal surfaces have many forms: shiny, matte, rough, pebbled, brushed, oxidized, textured, and satin. Nonpolished metals can be lighted with direct specular lighting, direct broad lighting, or indirect lighting. Direct broad lighting or indirect

For both these shots, one light was bounced off the background. Changing the position of the light changes the highlights on the owls.

In this set-up, one light was used with a white card reflector on the left. The white card is insufficient to cover the large ball bearing; as a result, the studio, lights, and photographer are reflected.

As in the picture above, one light and a reflector were used. However, the set has been covered with a 27-inch light cone. The line on the ball bearing is the seam of the light cone; the dot is the camera lens. Since it is almost impossible to avoid showing the lens in this situation, the dot must be removed later by retouching.

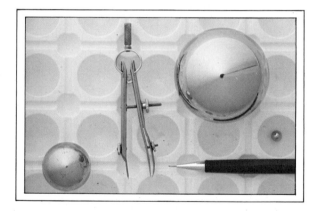

Once again, the light in this set-up comes from one light and a reflector. The background has been changed, and the seam of the light cone has been opened about one inch and covered with frosted plastic. This gives a specular highlight on the ball bearing, adding a touch of dimension to the shot.

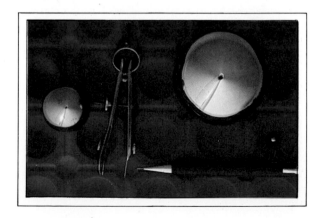

back lighting is best with low-reflectance metals. Adding a small specular light enhances the texture most often found in these metals. The exact positioning of the lights can only be determined from the camera position.

Highly polished metals require a bit more care because of their mirrorlike finish. Whatever is within reflective range of these objects will be imaged on their surfaces. Large reflectors, tents, or cones must be used to mask extraneous reflections. Cones or full tents with ceilings are necessary when photographing polished spherical objects. (Tent construction is detailed in Chapter 2.) I prefer a tent of translucent material with lights outside it, since this setup eliminates another source of distracting reflections. Placing the main light fairly close to the tent's surface gives a soft, feathered highlight on the object's surface. A second floodlight at a greater distance from the tent raises the overall luminance of the tent, effectively lowering the contrast of the metal object. Light cones are best used for jewelry and small objects. The conical sides produce shadowless, seamless lighting with only one light.

Tents aren't always necessary. A shiny metallic object with flat planes, such as a toaster, needs only a large, white reflector for each of the planes seen by the lens. A white card with a hole cut for the lens and held in place by an adapter ring is a good tent substitute when photographing flatware and jewelry.

Placing black or colored tape on the reflector surface or on the inside of the tent adds subtle lines to the object being photographed. The width, number of tapes, and colors can be determined only by experience.

TEXTURE LIGHTING

Awareness of subject texture is the photographer's first concern. Next are the degree of texture to be shown and the mood to be conveyed by this texture.

Texture should be subdued when the object suggests softness. A baby's blanket or a facial tissue would look like sandpaper if either were strongly texture-lighted. Fabrics such as corduroy or burlap demand texture lighting to illustrate their tactile qualities. I have photographed white-on-white sheer materials, where the background was a smooth, textureless thread and the pattern was a nubbly, highly textured one. Texture lighting was the only practical way to separate these two elements.

A direct light skimming the surface increases the three-dimensional relief of textured objects. For example, sugar cubes lighted with only a frontal, broad source are characterless white cubes. Adding a small spotlight placed at a very low angle in relation to the cubes emphasizes the granular quality of the sugar. Lighting the sugar cubes with only the texture light changes the entire character of the composition to that of an abstract texture study.

To achieve subtle texture lighting of flat surfaces, place a mini-spot so that the table surface bisects the center of the spot's lens. Then place a black card or gobo between the spot and the set approximately 1 inch above the table's surface. Texture light then influences only the textured surface and not the other props in the shot. This is an ideal lighting setup for delicate fabrics.

FABRICS

Fabrics generally require some form of texture lighting. Soft fabrics should have a broad-source side light for texture and a broad-source front light for overall luminance. Coarse, highly textured fabrics need strong texture lighting either with or without a fill light. Sheer fabrics show the greatest texture when photographed against a contrasting background. A side light adds shape and modeling to these

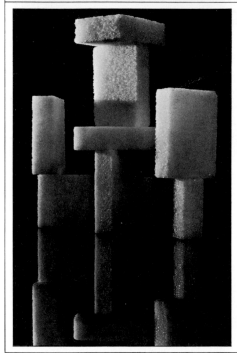

In these three shots, the effect of light on texture can be clearly seen. In the shot above, front light was used, and no texture is visible. In the shot above left, side light alone produced texture but no dimension. In the shot below, a combination of side light and front fill gives sugar cubes with both texture and depth.

fabrics. Another way to photograph sheer fabrics is to back light them totally, preferably with a spotlight. The threads used in sheers have a bit of sheen that is enhanced by specular light. See-through fabrics can be contrasted with an auxiliary set behind them. Balancing the light for this type of photograph requires care, as too much light on the secondary set will make it the dominant element.

Texture lighting for wood. Photographing unfinished or unvarnished wood requires some texture lighting; how much depends on the surface of the material. Exotically patterned woods, such as rose-

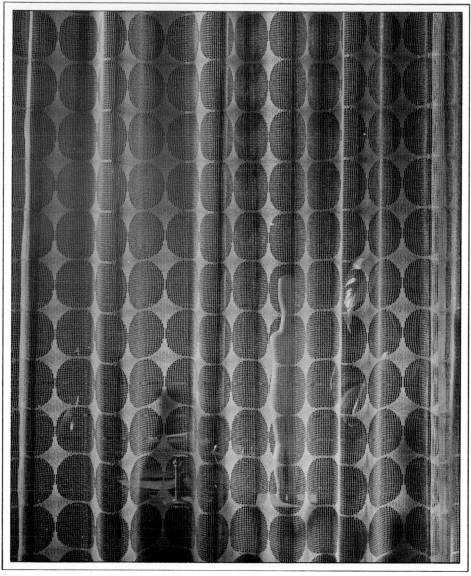

The client wanted to emphasize the see-through quality of this drapery fabric. The lighting used a 1,000-watt spotlight from the left rear of the set to light the holes in the drapes and cast the shadow of the bottle on the pleats. A second 1,500-watt floodlamp was used to light the front of the fabric. Care has to be taken to balance the background lighting and avoid overpowering the sheer fabric.

wood or burled maple, reproduce well under flat, textureless lighting. Varnished wood and furniture show the greatest texture when directly lighted. Varnished furniture is easier to shoot with dark backgrounds. Light backgrounds cause glare on the surface of the furniture, which obscures the texture of the wood. This

glare can be partially corrected by using a polarizing filter over the lens. Total control of glare is possible by polarizing the light source and placing a polarizing filter on the lens.

POLARIZERS

Light rays vibrate in all directions at right angles to the ray, rather like the hub of a wheel. A ray of light is polarized when vibrations in all directions but one are cut out. A polarizing filter does this to light passing through it. Light rays on the same axis as the polarizing filter, indicated by the dot at the edge of the filter, pass through the polarizer, but will be absorbed to a greater and greater extent as the polarizer is rotated to 90 degrees from this axis.

Polarizing filters can be used to reduce unwanted reflections on back-lighted photographs, very often saving a shot. Reflections from glossy metallic surfaces cannot be completely removed, as these reflections are not polarized. Complete reflection control is only possible if both the light source and the camera are polar-

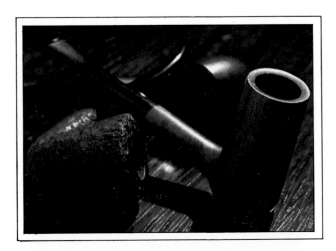

To photograph the pipes at top right, a polarizing filter was used, but back light was still allowed through. In the shot at bottom right, the polarizing filter was rotated 90 degrees, removing all specular highlights. The lighting and exposure was the same for both shots.

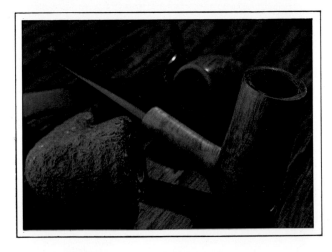

ized. Large polarizing filters for lights are available at professional camera stores or scientific supply houses. Polarizing filters can also be used to darken the light of the sky with no change of color and as variable haze filters. A large sheet of polarizing material with either stressed plastic or rumpled cellophane laid on it and a polarizer over the lens will give most unusual color effects and will make interesting theatrical backgrounds.

BALANCING LIGHTS

There are times when the photographer must either work with existing lights or balance existing lights to match the photo lights.

When working with existing lights only, it is simply a matter of placing the appropriate filter over the lens. If the light source is fluorescent, mercury vapor, or sodium vapor, the type of bulb must be determined, as each type requires different filtration. The Appendix lists correction filters for each type of light.

Sometimes the still-life photographer must use photographic lights along with existing light. Tungsten lamps can be corrected to daylight balance by placing dichroic filters or Roscoe gels over the

photolamp and shooting daylight-type film. An alternative method used by movie photographers (cinematographers) is to cover the windows with tungsten conversion filters (EK 85B) available in large rolls from Roscoe Industries. Fluorescent lights can be converted to either daylight or tungsten balance by using Roscoe gels of the appropriate color; these are available in sleeves designed to fit fluorescent tubes. This is an expensive way of correction, used only if you have a large budget, but it is the only way to get accurate color, short of changing all of the fluorescent tubes to color-accurate ones. An alternative method of changing fluorescents to tungsten or daylight balance is to filter the additional light sources to match the fluorescent lights and then to place a fluorescent correction filter over the lens. Cool-white fluorescent lights can be approximately corrected to daylight balance by bouncing a 500-watt photoflood off the ceiling near the fluorescent. This last method should be tested if critical color is required.

COLORED LIGHT

Colored light can be used for special or theatrical effects in still-life photography,

To capture the flame of this blowtorch, High Speed Ektachrome, type B, was used with a floodlight to illuminate the torch itself.

The candles in this shot were made by the photographer and placed into the cars. The candlelight gives the overall light; a very low wattage floodlight was bounced off a white card for minimal fill.

To get this shot using a practical light as a prop, a clear 75-watt lightbulb was wired in series with two others to reduce the light and avoid flare. The background is a slide of a sunset projected onto white seamless paper. The photographer used a foot switch to turn on the lightbulb for 14 seconds during a total exposure time of 110 seconds.

although I feel that in too many cases they are a lazy solution to lighting or compositional problems. Colored gels are available at theatrical and artist supply houses in an assortment of colors. The photographer's taste is the limiting factor in the choice of these colors. When using colored filters, try to have complementary colors on either side of the subject. For example, when red is used over the main light, its complement, cyan, should be placed over the fill light. Keep the lighting ratio low. There will be red highlights on one side of the set, cyan shadows on the other side, and correct color where they overlap. Weaker-colored gels can be used to reinforce a pictorial mood. You might choose to use a pale-orange gel to simulate light from a candle or a fire. A blue gel projected on blue seamless paper gives realistic skies with miniature sets. I prefer the use of colored card reflectors and bounced white light. The effect is considerably more realistic.

OTHER LIGHT SOURCES

Light sources themselves can be an integral part of the composition. A lamp, a match, a blowtorch, or a fire makes an excellent prop. These props are known in the movie industry as practical lamps. The lights from practical lamps may or may not influence exposure.

Light from a candle 1 foot from the subject will give an approximate exposure

It took two days of shooting to get this shot. Because of the number of highlights needed, a variety of card reflectors, spotlights, and snoots were needed. The liquid in the sherry glass was highlighted by a small mirror taped into place out of sight on the antique stereopticon.

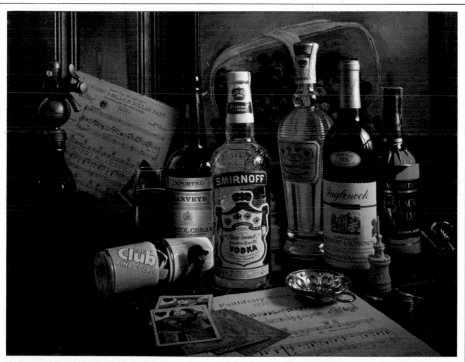

of 1 second at $f/1.4$ with Kodachrome 64. If the candle were 6 inches from the subject, the Kodachrome 64 exposure would be $^1/_4$ second at $f/1.4$ Candlelight itself would be approximately 2 stops less exposure, or $^1/_{15}$ second at $f/1.4$.

The best way to determine practical light exposures is to spot meter the light and increase the exposure one f-stop if you want tone in the light and two f-stops if you want the light to be white.

LOCAL CONTROL OF LIGHT

It is not always possible to regulate every effect of a light without some local control. The coverage of a spotlight can be reduced by using snoots—black tubes of varying lengths mounted on the front of spotlights. The longer the snoot, the narrower the beam of light. Three-inch-deep grills made from black cardboard and placed in front of a soft box restrict the coverage of the soft box to its dimensions when fairly close to the subject, while still maintaining its broad light effect.

Gobos, flags, and targets are used to mask and restrict the coverage of light. A gobo, as described in Chapter 6, is a piece of black cardboard or plywood, of any shape or size, mounted on a stand. A flag is a small gobo, and a target is a small, round flag. A scrim, also described in Chapter 6, is a translucent gobo or flag. Interesting effects can be achieved using cookies. A cookie is a varigated, opaque or translucent flag used to cast patterns or to create a mottled look on otherwise dull backgrounds.

Mirrors, bits of mirrors, small pieces of aluminum foil, and white reflectors are used locally to highlight areas in the composition. These small reflectors often are hidden on the actual set. Localized lighting of small areas can also be created by snaking fiber optics through holes drilled in the shooting table. The solutions to lighting problems, particularly in advertising photography, are often more imaginative than the picture composition itself.

SHADOWLESS LIGHTING

The sweep table is a means of shooting shadowless pictures. It is in essence a curved light table. A variation of a sweep table is the method used to make Superman fly in films.

Fiber optics transmit light along their length. They can be curved around to light awkward spots of a set.

Toothbrushes lit only by a spotlight are heavily shadowed, as the picture on the top left shows. In the picture below it, the toothbrushes are lit from underneath with a sweep table, giving shadowless lighting but retaining a three-dimensional feel.

Sometimes specular light should be used in conjunction with a tent. This photograph of a faucet and running water was taken with a direct main light to the right and slightly behind the faucet. This light was bounced from two large foam-core reflectors, one with a hole cut for the lens and the other parallel to the left side of the faucet. Blue strips of paper attached to this reflector added color accents to the metal. The direct light supplied brilliance to the water and interesting specular highlights to the faucet.

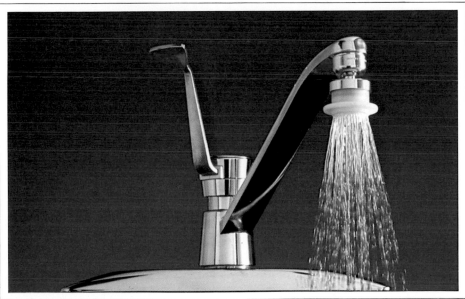

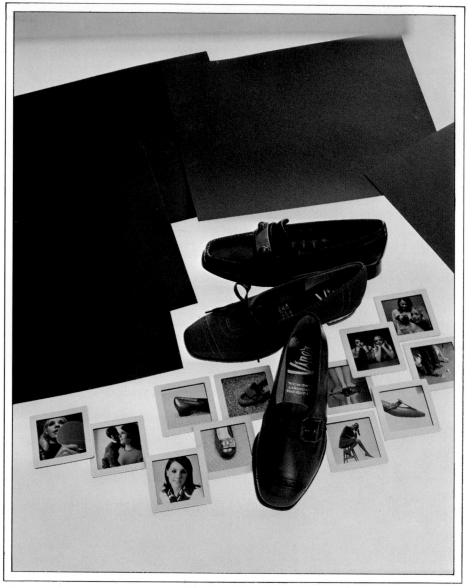

This shot was made on a sweep table to show the transparencies. The shoes were lit with a broad source light and reflector to get soft highlights on the leather. The black cards were laid down to reduce flare from the excessively white background of the sweep table. The cards were later removed in engraving, a common advertising practice.

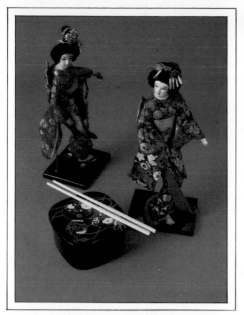

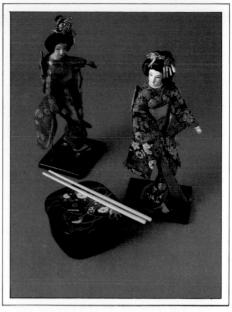

This shot is strictly reportorial, illustrating no mood. The light is from a broad source in an intermediate major key.

The mood here is lower key, created by the addition of one spot on the doll's face.

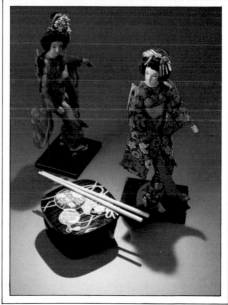

The overall mood of this shot has been lowered and made more dramatic.

The emphasis has been altered here, changing from the dolls to the lacquered box and chopsticks.

To highlight the label of the vodka bottle, the crested glass, and the jeweled vodka cup, a 150-watt spotlight was placed to the right. A second spot was directed onto the brown background to give luminescence to the martini in the background and the drink in the left foreground.

To photograph these miniature brass musicians, a broad source light was directed onto the set from the left. A card reflector was placed to the right. A spotlight was directed onto the background at about the waist level of the musicians to modulate the background, and a third light was bounced from the ceiling to light the front of the musicians and the gazebo. No direct light was possible because the gazebo was painted on glass.

Two umbrellas with attached flash heads were laid on seamless background paper placed on a floor to provide almost shadowless lighting for this antique gun. The photographer then bent over, found the point of least glare through the viewfinder, and snapped the shot.

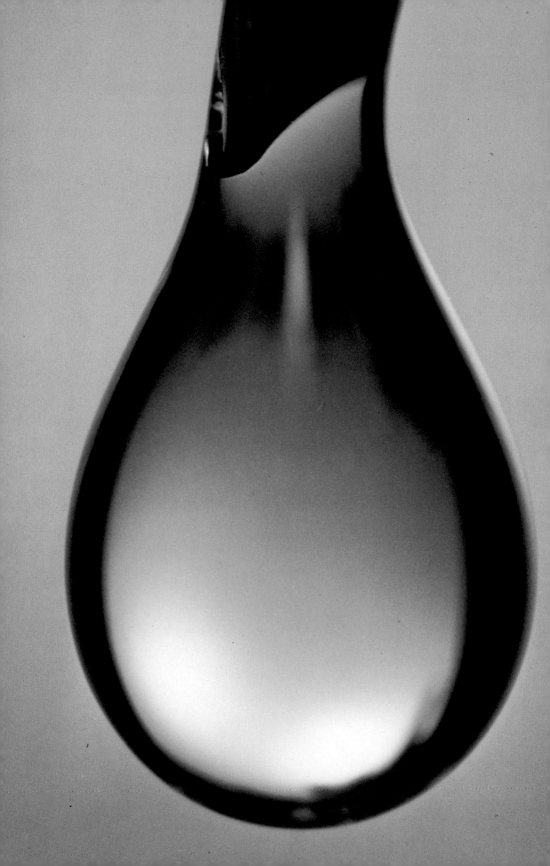

Macro Photography, Miniatures, and Set Building

Macro photography opens up a realm of new photographic images created by magnification. The term *macro* generally refers to the reproduction of images on film at sizes ranging from one-half to ten times life-size. For greater magnifications, a microscope is needed. Macro photography is used extensively in science, industry, medicine, and advertising, though it is also done more and more for the sheer aesthetic appeal of exploring abstract forms and new dimensions taken on by greatly enlarged subjects.

Effective macro photographs must overcome three problems: depth of field, exposure calculation, and lighting. As might be expected, the best solutions are based on a thorough understanding of the problems, combined with ingenuity and imagination.

DEPTH OF FIELD

The important thing to remember in macro work is that the greater the magnification, the smaller the depth of field. This means that a three-dimensional subject photographed at a magnification of ten times life-size, for example, would be unlikely to be in focus from front to back. The question is, how much of the subject would be in focus, and what can be done to improve the situation?

Determining magnification. Magnification is expressed as a ratio of the image size on film and the actual size of the subject. The ratio is found by dividing the image size by the actual subject size. At its simplest, this is done by physically measuring both the subject and its image on the viewing screen. This method is impractical, however, if your camera's viewing screen in inaccessible, as it is in many 35mm single-lens reflex cameras. In that case, place a ruler marked in millimeters next to the subject. Look through the viewfinder, determine how much of the ruler is visible, and divide the long dimension, in millimeters, of the film size you are using by the number of millimeters shown in the viewfinder. Remember that in the 35mm format the film is 24 × 36 millimeters.

Circle of confusion. When the lens is sharply focused on the subject, light in the form of points strikes the film plane. In front of or behind the film plane, the light, because it is not focused on that plane, registers as a disk or circle. When these circles are small enough, they are virtually indistinguishable from points, and the image still seems to be in acceptable focus. It is possible to calculate just how large the circles can be before the photo seems out of focus by using the following formula: divide the focal length of the normal lens in inches for the particular format by 1,000 to get the maximum permissible circle of confusion in inches; divide the focal length in millimeters by 2,000 to get the result in millimeters.

The larger the format, the larger the

To photograph this oil drop at a 7X magnification, a 35mm lens was reverse-mounted on a 35mm camera. An exposure increase of six stops was required. The lighting came from a strobe directed through opalized plastic.

permissible circle of confusion. The larger the permissible circle of confusion, the greater the depth of field. The chart on the next page gives the dimensions of the maximum permissible circles of confusion for various formats.

Format	Circle of confusion (inches)	Circle of confusion (millimeters)
35mm	.002	.025
2¼ inch	.003	.04
4″ × 5″	.008	.08
8″ × 10″	.012	.15

Calculating depth of field. The depth of field scales engraved on camera lenses are not very helpful when doing macro work, requiring the photographer to calculate depth of field on his or her own.

At small magnifications depth of field will be approximately one third in front and two thirds behind the subject. At larger magnifications it will be evenly divided.

First, decide what *f*-stop you would like to use. Then look up the dimensions of the maximum permissible circle of confusion for your format (use the chart above). Next, determine the magnification of the subject. You now have the information you need to calculate depth of field. Multiply the *f*-number by the circle of confusion. Multiply this product by the magnification plus one. Take this product and divide it by the magnification squared. The total depth of field will be double the figure derived by using the formula.

Magnification	Depth of field	Depth of focus
¹/₁₀₀:1 (.01:1)	4040 mm	.404 mm
¹/₂:1 (.5:1)	2.4 mm	.6 mm
1:1	.8 mm	.8 mm
2:1	.3 mm	1.2 mm
3:1	.18 mm	1.6 mm
4:1	.125 mm	2.0 mm
8:1	.056 mm	3.6 mm
16:1	.026 mm	6.8 mm

Depth of focus. Depth of focus is the distance the film plane can be moved without refocusing the lens while still maintaining an acceptably sharp image. As depth of field gets smaller, depth of focus gets larger.

When a lens is used in reverse mode, particularly with a view camera, the depth of focus becomes the effective depth of field.

Normal depth of focus is calculated by multiplying the *f*-number of the lens by the circle of confusion, and then multiplying that product by two. Close-up depth of focus is calculated by using the same formula, but then multiplying the result by the magnification plus one. As the chart below shows, at magnifications much larger than life-size depth of focus is greater than depth of field.

FOCUSING

In close-up work focus is critical. The first step in obtaining sharp focus is a sturdy tripod. Any vibration of the camera is magnified in proportion to the magnification factor, so it is essential to avoid camera motion. Focusing in close-up work is accomplished by moving the entire camera, not by rotating the lens. A geared track is the easiest way to move the camera the small distances necessary for critical focus. A 10× magnifying viewfinder is also a big help.

Reversing the lens. Most standard camera lenses are designed to work best when the lens is focused at infinity and the rear element of the lens is one focal length from the film plane. In other words, most lenses are designed for a small image distance (the lens-to-film distance) and a large object distance (the lens-to-subject distance). However, when shooting close-ups of extreme magnification, the lens is positioned further and further from the film plane as the magnification increases, and thus the lens gets further and further away from its optimal focus position. For

The depth of field in this shot was about an inch. The magnification here is about 5X; a 20mm lens with a 10mm extension tube was used on a 35mm camera. The front element of the lens was about 3/8-inch from the dice and acted as a reflector for fill light.

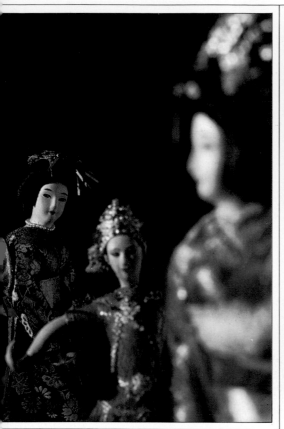

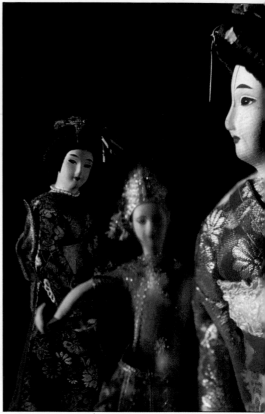

The focus in this shot is on the doll in the background, which was about 31 inches from the normal lens. The other dolls are out of focus because the depth of field at this magnification (1:12) is only about one inch.

A + 2 split-diopter lens was used for this shot. Both the near and far dolls are in focus; the middle doll falls along the edge of the half lens and is out of focus.

example, at a four-times magnification using a 50mm lens, the subject is 62.5 mm from the front of the lens, and the film is 250 mm from the rear of the lens.

If the lens is taken off the camera and mounted in reverse so that the rear element of the lens faces the subject, the optimal focus position is reestablished. Reversing the lens leads to increased sharpness, greater depth of field, and a somewhat flatter field at great magnifications. Reverse-mode lens adapters (reversing rings) are inexpensive and available for almost every 35mm camera brand.

Through-the-lens meters on most cameras are still operative when the lens is

reversed; automatic cameras, however, must be used in the manual mode. Again, either the camera or the subject must be moved to bring the subject into focus. For additional magnification, use reversing rings or bellows to gain more lens-to-film distance. Reversing the lens works well with wide-angle and normal lenses; it is rarely effective with long-focus lenses.

Split-diopter lenses. There are times when a composition may require both an object at 1 foot from the lens and an object at infinity to be in focus. The solution is a split-diopter lens. These lenses are supplementary attachments that are made of a close-up lens cut in half.

Place the split lens over the camera lens and rotate it until the diopter part covers the close object and the clear part covers the rest of the scene. Both subjects will now be in focus. When using split-diopter lenses, avoid compositions that have elements in between the near and far focal planes, because these elements will be out of focus. Try to line up the split in the lens with a straightedge in the background.

EXPOSURE

In macro photography the lens is extended, and the distance from the rear element of the lens to the film plane is greater than normal. Because of this, there is light falloff to the inverse square, and exposure often must be increased. If your camera has a through-the-lens meter, determining the exposure increase is no problem—the meter automatically makes the compensation. If your camera does not have a through-the-lens meter, you'll have to calculate the exposure increase yourself.

There are basically two ways to increase the exposure: use a slower shutter speed or a larger aperture. Whichever method you choose, you must first compute the exposure factor. Use the method explained on page 125 to find the magnification. Take that number, add one to it, and square the sum. The result is the exposure factor.

To increase the exposure by using a slower shutter speed, first use a light meter to determine the normal exposure. Then multiply the indicated shutter speed by the exposure factor to find the corrected shutter speed.

The other alternative is to adjust the aperture. To do this, use the light meter to determine the normal exposure. Then convert the exposure factor to *f*-stops (an exposure factor of 4 × equals two stops) and open the aperture by the indicated amount.

LIGHTING CLOSE-UPS

The primary problem when lighting a high-magnification scene is getting light onto the front surface of the subject. Very small lights—such as gooseneck, high-intensity lamps, or fiber-optics lights—will help solve this problem. Small mirrors, such as those used by dentists or machinists, are useful for directing concentrated light onto the subject. An advantage to the machinists' mirror is that it can be swiveled.

For broad, overall front lighting, a white or aluminized card placed around the lens is very helpful. This technique works best when used with small short-focus lenses, because their diameter is about three quarters of an inch. This gives a relatively larger reflectance surface around the lens.

Beam splitters. A beam splitter is another way of getting light onto the front of the subject. Beam splitters are optically pure reflectors made of very thin glass or plastic to eliminate distortion. A very serviceable beam splitter can be made by stretching plastic wrap (the type found in grocery stores) over an embroidery hoop. Then heat the plasticwrap slightly (and carefully) over a lightbulb so that it shrinks and stretches to make an optically flat surface.

To use the beam splitter, set up the scene with a light at a 90-degree angle to the lens axis. Place the beam splitter opposite the light, and angled 45 degrees to the lens axis. The beam splitter will reflect about 50 percent of the light onto the subject. Put a black card opposite the light to prevent any light reflection from the lens side of the beam splitter that could cause lens flare.

MINIATURE SETS

Miniature sets are used by still-life photographers either to save the money needed to go on location or to create

The toy soldiers in this picture were used to illustrate Winston Churchill's chronicle of the Battle of Omdurman. The goal was to show the 21st Lancers being attacked by the Sudanese. Sand was poured on a table and mounded to look like a desert surface. Then very fine, dry paint pigment was sifted on the sand to create a brilliant red desert. A miniature palm tree was placed in the background to suggest an oasis. A red darkroom bulb on the horizon simulated a sunset. The red was intensified by using red seamless paper as a backdrop and filtering the light through red gels.

unusual or abstract effects. In either case, the quality of the model is of primary importance. A poorly built model or one made to too small a scale will look shabby. Model-making is a fussy, detailed chore. Some knowledge of how to achieve the correct perspective and scale effects helps considerably.

Once the scale of the model has been chosen, say 1 inch to the foot, it is possible to determine the proper lens focal length to equal a normal lens with a full-scale set.

First, determine the magnification. As explained earlier (see page 125), divide the image size by the object size. Next, find the magnification of the set if it were full size, and add one to that figure. Do the same thing for the magnification of

the scale model, again adding one. Divide the first number by the second; that is, divide the magnification plus one of the full-scale set by the magnification plus one of the scale model. Take this result and divide it again by the magnification plus one of the scale model. Multiply this number by the focal length of the normal lens for the format of your camera. The product is the correct lens focal length to use to equal the normal lens for a full-scale set. When using this procedure, remember to do the calculations in millimeters if you are using a 35mm camera. Remember, also, that this procedure is only necessary if you want to match the perspective of a normal lens. Straight macro work can be done with a lens of any focal length.

To simulate the Lascaux Cave paintings, chicken wire, papier mâché and real rocks were used. After the papier mâché dried, it was painted with thick acrylic house paint; handfuls of sand were thrown on this surface while it was still wet to simulate a sandstone surface. The surface was then alternately sprayed with gold, brass, and copper lacquers. The cave paintings were copied from a book on the subject. The model was placed on the vinyl floor (the real subject of all this) and real rocks were strategically placed on the set. In the test shots, the real rocks looked artificial, and had to be painted in the same way as the papier mâché. Key lighting was supplied by a 2,000-watt spotlight; two 1,500-watt floodlights were used for fill lighting. A small spot was directed at an opening at the back of the ''cave'' to create an illusion of great depth. This set was about seven feet wide and five to six feet deep.

The sand castle was made in the usual way with real sand, but a mixture of glycerin and water instead of plain water was used as a binding agent. The glycerin kept the castle moist and standing for the eight days it took to get the client's approval of the pictures.

Building this spiral staircase with diminishing scale was an enormous challenge. The base was made of ¼-inch plywood cut in a spiral shape and bent and secured to form a ramp. The walls and balustrade were formed from one-sided, flexible, corrugated cardboard. The bannister rails were made from varying thicknesses of rubber and copper tubing; the rubber tubing was slit to fit over the cardboard balustrades. The bas-relief decoration was created with wood putty. Housepaint was used on the walls and picture-framers' gilding was used for the gold decoration. The silver globe at the bottom of the spiral was a Christmas tree ornament. Two 1,500-watt floods and four 150-watt spots were used to light the model. The depth of field was purposely limited so that the details of the floor material at the further points would be obscured, conveying a sense of distance. (See the Appendix for more information on model calibration.)

This simulated skyscraper was made using ¾-inch plywood; the final dimensions were 48 × 16 inches. The colored chips (actually color samples of the client's product) were used to suggest lighted windows. The dark windows were ⅛-inch black Lucite. Reflections in the black windows, to suggest a neighboring building, were created by randomly draping white strips of paper from a black card above the set. Key lighting was created by two electronic flashes bounced from a large white reflector. Two smaller flashes were directed on the bottom of the blue seamless backdrop paper to suggest a night sky. One flash was used as a cross-light to add highlights to the edges of the black windows. A broad front light was used to light all 72 color chips evenly.

Building the set. Almost any material can be used to build a set. Ingenuity is the key. Pebble-surfaced mat board that has been varnished makes an excellent waterlike surface when shot with black-and-white film.

Scale models of automobiles, airplanes, military hardware, ships, trains, and rocket ships can be used to create realistic or abstract sets.

Weather and light effects can be created by modifying the lighting and using a few tricks. Low-lying fog, for example, can be simulated by placing dry ice and hot water in a tray close to the set, or by gently blowing cigarette or pipe smoke across the ground surface. A starlit night can be suggested by punching very small holes in a backdrop of dark-blue seamless paper; then light the scene from behind the backdrop, and place a star-effect filter over the lens.

The background for this shot was a blow-up of the etching, toned with coffee for a sepia color, and mounted on a curved board for a wrap-around look. A broad-source light was aimed down at the set and reflected back by a white card aimed upwards.

One of the most famous view cameras made—the Deardorff 8 × 10-inch at its full 30-inch bellows extension. Note the opposite tilts on the front and rear standards, and that the front has been swung and dropped as well. *Photo courtesy L.F. Deardorff & Sons, Inc.*

9

View Cameras

Basically, a view camera consists of a spring-loaded camera back that accepts a film holder, a ground glass for viewing and focusing, and a front lens standard. The camera back and lens standard are connected by a light-tight bellows and are mounted on a sliding or geared focusing track. Most view cameras have a rising and falling front lens standard and allow lateral swings and vertical tilts of both the front and rear standards.

SWINGS AND TILTS

It is the view camera's capacity for swings and tilts that makes it such a valuable tool for the still-life photographer. To maintain correct focus and perspective in a photograph, the film plane of the camera must be parallel to the subject. The most familiar example of the distortion that can occur if this is not so is the keystoning effect that occurs when the entire camera is tilted to get all of a tall building into the frame. In the resulting photograph, the vertical lines will seem to converge towards the top of the picture, and the building will seem about to topple over. By using a view camera that allows just the front lens standard to be raised, getting all of the subject into the frame while the film plane remains parallel to the subject, the perspective will be correct in the final photograph.

The swings and tilts of the view camera can be used for much more than just correcting vertical perspective. Vertical tilts of the camera back are used for parallax correction; front-standard tilts are used for focus correction. Parallax correction of horizontal lines is achieved by using lateral (sideways) back swings. Front-standard swings can be used to alter the horizontal focus axis, and rising and falling standards can be used to change or correct the angle of perspective.

IMAGE SIZE AND POSITION

The image of the subject shown on the ground glass of a view camera is inverted, a feature that takes a little getting used to. With practice, however, you will be able to judge perspective, composition, and lighting upside-down.

View cameras come in all sizes, formats, choices of construction material, types of focusing rails, and degrees of sophistication. There are view cameras today that accept 2¼″ × 3¼″, 3¼″ × 4¼″, 4″ × 5″, 5″ × 7″, 8″ × 10″, 11″ × 14″, 20″ × 24″, 8″ × 20″, and 12″ × 20″ film sizes. In addition, many view cameras have reducing backs that allow 4″ × 5″ film to be used with 8″ × 10″ cameras, or 2¼-inch roll film to be used with 4″ × 5″ cameras.

Increased image size is a valuable reason for using a view camera. For example, a small detail in a composition might be rendered with four grains of silver on a 35mm negative; the same detail would be rendered with 36 grains of silver on a 4″ × 5″ negative, and 110 grains of silver on an 8″ × 10″ negative.

PERSPECTIVE AND DISTORTION CONTROL

As already discussed in the case of architectural photography, distortion correction is another prime reason for using a

view camera. As the illustrations on pages 140–142 show, keystoning, reverse keystoning, and other problems of distortion can be eliminated with the swings and tilts of a view camera.

Sometimes a little keystoning is more acceptable to the eye than absolutely vertical parallel lines, particularly if the shot is taken with a wide-angle lens. When the photo shows parallel verticals and the eye expects to see some keystoning, the eye tends to overcompensate. The result is an optical illusion that fools the viewer into thinking that a cube, for example, is wider at the bottom than it really is. At that point, whether to correct for keystoning or not becomes an aesthetic choice.

In still-life work, there are times when a change of perspective is needed, either for its aesthetic value or simply because the studio is too small. In either case, the view camera makes it easier.

If the studio is too small (or the props are too large), the view camera can be used to take two or more photos with corrected perspective. These photos can then be stripped together to create the complete scene with almost perfect perspective.

A problem often encountered when using the swings and tilts of a view camera is ellipsoid distortion of circular and oval objects, particularly in the lower corners of the picture frame. This phenomenon has plagued food photographers for ages. They have tried every trick in the book to solve it. They have used extremely long lenses to no avail; they have raised the outer rims of dishes with small shims, again to no avail; they have argued with art directors, trying to convince them to move the dishes into the center of the frame, and have been frustrated by their refusal.

Occasionally, a set is so large that two shots must be joined to create the final photo. Use the swings of the camera to keep the camera back parallel to the set while maintaining the correct perspective for each photo of half the set. In the final photo, the join line visible here would be retouched.

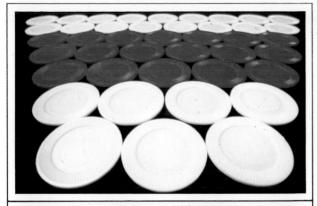

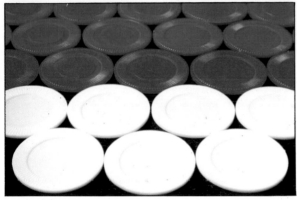

These two shots show the problem of ellipsoiding and how it is resolved. In the shot on the top, the poker chips were shot with a 20mm lens. Ellipsoiding is quite obvious in the foreground. In the shot on the bottom, a somewhat longer lens was used, and the camera back was tilted forward. Although a small amount of ellipsoiding is still visible in the foreground, the overall effect is much improved.

The solution is actually quite simple. Tilt the camera back forward, and then treat the camera as if it were a fixed-format camera. Use a slightly longer-focal-length lens. There may be some keystoning, which the eye will accept, but there will be less ellipsoiding, which the eye will reject.

Swings and tilts are primarily designed to correct distortion, but you can have fun with them as well. An egg can be made into a perfect sphere by tilting the camera back forward; the egg can be stretched by tilting the camera back away from it. Unfortunately, no one has figured out how to use swings and tilts to make a cube shape from an egg, although swings and tilts can do some rather remarkable things to a cube, as the photos on pages 140–142 shows.

FOCUS CONTROL

Increased focus control is a major plus with view cameras. This focus control is used for two purposes: to increase the relatively shallow depth of field inherent in view cameras, and to maneuver the zone of sharp focus in the picture.

Depth of field can be increased by tilting the front or back of the camera so that the section of the film recording a near image is further from the lens than the section recording a far image in the same shot.

In addition to bringing separated subjects into focus in the same shot, the view camera can be used to manipulate the zone of sharp focus. In a straight-on shot using no camera movements, the zone of sharp focus extends in a horizontal band

When a cube is photographed from a 45-degree frontal view, with the camera back parallel to the cube and the cube centered in the frame, the picture shows only the two vertical planes facing the lens.

To show the two vertical planes and the top of the cube, the camera is raised, keeping the camera back parallel to the cube, and the lens is lowered. No keystoning is apparent.

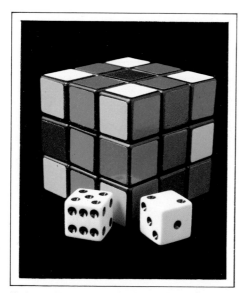

If the entire camera is aimed downward, reverse keystoning is the result.

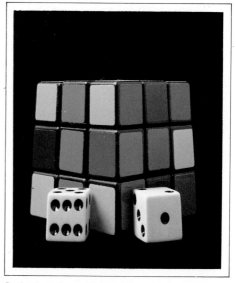

Swinging the entire camera further towards the horizontal exaggerates the keystoning effect.

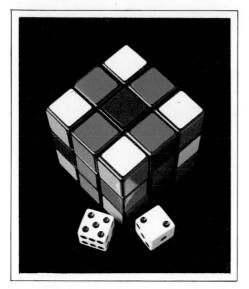

Exaggerated keystoning is produced by raising the camera back and lens 15 degrees above the horizontal.

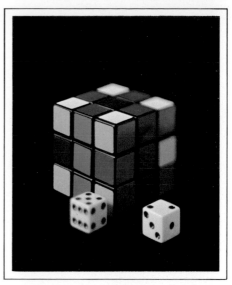

To focus along the left plane of this Rubik's Cube, the camera back was tilted back about 15 degrees and the front standard tilted forward about 12 degrees.

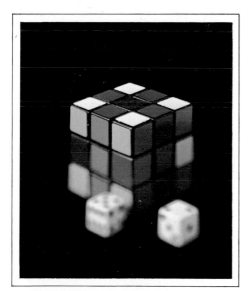

The focus in this shot was the top of the cube. The front standard was tilted forward about 30 degrees; the camera back was tilted back about 15 degrees.

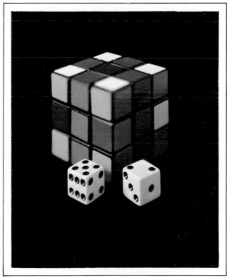

The side planes of the cube were kept in focus by a lens swing of 15 degrees to the right. The back was tilted about six degrees.

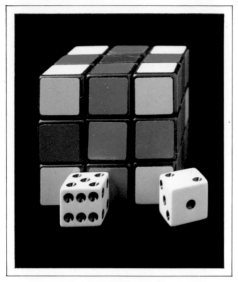

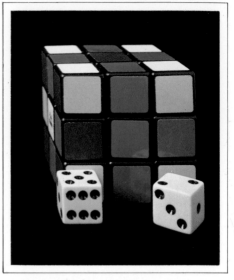

Left perspective was corrected here by swinging both the camera back and the lens 20 degrees to the left.

Right perspective was corrected here by swinging both the camera back and the lens 20 degrees to the right.

Front focus was created here by tilting the camera back 15 degrees and the front standard 12½ degrees.

To get this distorted shot, the camera was tilted down and the back swung to the left; the front was swung to the right.

across the scene. By using swings, the zone of sharp focus can be made to extend diagonally across the scene.

When adjusting the view camera for focus control, the recommended procedure is to make all plane-of-focus adjustments with the camera back, and then to readjust the camera to correct parallax. If the camera has built-in micrometer adjustments on the front standard and the camera back, make the correction by tilting the camera back. Note the degree of tilt, return the camera to the original position, and tilt the lens forward by the same number of degrees. Cameras without micrometers should be focused on the subject, and the plane of focus should be set by tilting the lines either forward or backward. Alternatively, tilt the back, measure the degree of tilt using a hand-held protractor, and make the front-standard adjustments accordingly.

It is possible to swing or tilt the camera beyond the capability of the lens, causing vignetting. This will usually show up as a dark, curved area at the top of the picture. With black or very dark backgrounds vignetting is not a problem. However, with light backgrounds it can be disastrous. A simple way to avoid vignetting is to look at the lens from the film's point of view. Most ground-glass viewing screens have their corners cut off to allow air to escape as the bellows is moved. A secondary, but probably unintentional, function of these cuts is to allow you to see if the capability of the lens has been exceeded. If the lens has been tilted forward, look through the hole at the top of the camera back and stop the lens down until a complete circle of light is visible. If there is no circle at the smallest aperture, then the lens has been tilted too much. If the lens has been tilted backward, view the aperture from the lower portion of the camera back.

Lens shades are another cause of vignetting with view cameras. Be careful. Also be sure that the bellows doesn't sag when extended—yet another cause of vignetting. If necessary, support the bellows with a block of wood.

A basic rule of thumb when using swings and tilts for focus control is to set them for overall sharpness in the plane covering the greatest distance range. Then stop down the lens for the depth needed to bring into focus the elements at right angles to the focal plane. There are times when setting the plane of focus at an intermediate position will allow the use of a larger aperture.

DIFFUSION

Controlled diffusion of the image is much easier to achieve with a large camera. One inexpensive and convenient method that creates diffusion is to place a sheet of clear glass coated with rubber cement about one focal length in front of the lens. While viewing through the ground glass, rub the cement off the glass until the desired effect is achieved. Diffusion photography should be done at the widest possible aperture; stopping down the lens brings the diffuser itself into focus.

SUBJECT PLACEMENT

To the professional advertising photographer, perhaps the greatest advantage of a view camera is the grid marked on the ground-glass viewing screen. It is invaluable when absolutely accurate placement of the subject is of great importance, such as for an ad layout in which the headline, added later, must be integrated with the picture. The layout can be scaled to the grid on the ground glass, and the camera can be manipulated so that the subject fits where it belongs.

Finally, remember to double-check everything, especially exposures, when using a view camera. Film and processing are considerably more expensive for the large formats.

The plane of focus in this shot was along the frosting of the cake, a good example of the use of a view camera. A wide-open aperture was used to get a blurred background.

Matching perspective is much easier with a view camera. To create this unusual shot, the background (an enlarged etching) was curved to match the perspective lines of the upper stereo component, and the camera was aligned with right edge of the equipment. The eight-inch lens was shifted ten degrees to the right. To show the bottoms of the stereo components, this shot was set up upside-down, with the equipment resting on boards extending through the background. Note the slight ellipsoiding of the dome caused by the camera swing.

Special Effects

Special effects in still-life photography encompass motion, multiple exposures, zooming, superimposition, and front and rear projection. These are all gimmicks used to add drama and impact to a scene or to solve apparently unsolvable technical problems.

Unfortunately, special effects are all too often used to camouflage a poor idea or a weak design; that's the problem with gimmicks. Still, a weak design can sometimes be saved with a gimmick, while a strong composition can only become stronger.

Which is more dynamic, a glass of beer with its head going flat, or one with a bit of foam running down the side of the glass? Isn't a golf ball splashing into water more exciting than one lying in the rough? Wine pouring into a glass with swirls and gyrations is a far more exciting shot than a dormant glass. A wise old advertising person once pointed out, "We're not selling the steak; we're selling the sizzle."

Photography is unique in its ability to falsify in a most believable manner. A painter can suggest motion or multiple images, but when the photographer does it, the viewer believes that what he or she sees really happened.

MOTION

Artificial motion can be added to a still life by mounting a board on a heavy-duty tripod, and then mounting the camera and a small set on the board. Make a time exposure, panning the entire camera/set assembly slowly to create a blurred background.

The same procedure can be used with a large turntable or lazy Susan. Place a fixed surface over the spindle of the turntable to allow the surrounding forms to revolve around the main subject. A longer exposure totally obliterates the forms surrounding the primary subject; a shorter exposure retains these shapes. Dark backgrounds are required for this type of shooting. In fact, black backgrounds are preferred whenever slow-shutter motion studies are being shot.

A rotating shutter placed in front of the lens creates a stroboscopic effect when used with the above techniques. With a little ingenuity, you can make an inexpensive rotating shutter. You need plywood, black paint, thin cardboard, and a small, variable-speed, battery-operated motor (available from hobby shops).

First, purchase two pieces of plywood 12" × 12" × ¼". Place one piece on top of the other, and drill a 2½-inch diameter hole halfway down one side and an inch from the edge of both pieces. Drill a small hole through the center of the pieces. Next, cut the thin cardboard into a 12-inch diameter circle, and paint it flat black. Measure off the circle into 45-degree wedges, and cut out every other wedge, leaving enough cardboard at the

Action in still-life photography can show the subject, the environment, or both in motion. This shot of a golf ball splashing into water shows cause and effect, where both elements are in motion.

Shots of liquids are generally more exciting if they are taken to show stop-motion, as this photo shows. A stationary prop placed in the water at the foot of a waterfall, for example, will have greater impact if the water appears to be in motion. To show motion in a liquid, use a shutter speed fast enough to keep the shot crisp while allowing a slight amount of blur to suggest the flow of the fluid.

A turntable was used to create the blurred-motion effect in this shot. The turntable was rotated during the second half of a long exposure.

A combination of a rotating shutter and turntable produced this special effect.

By rotating the turntable during an exposure with a rotating shutter covered with separation filters, color fringing can be seen. In this case, Wratten filters 29 (red), 47 (blue), and 61 (green) were used, along with a .40 neutral density filter to balance the red filter to the others.

center of the circle to hold it together. Now mount the cardboard shutter between the two pieces of plywood, separating the plywood by ⅜-inch. Attach the drive shaft of the motor to the center of the shutter. Place the entire assembly in front of the camera lens, preferably on a separate support to eliminate vibration. The exposure factor for this shutter is one stop, regardless of the speed at which the motor runs. To use the rotating shutter, set up the assembly, darken the room, light only the set, and open the camera shutter with the shutter and turntable in motion.

An advanced variation of the stroboscopic effect of a rotating shutter and turntable can be achieved by placing a red separation filter plus a .40 neutral density filter over one of the openings in the shutter, a green filter over the second opening, a blue filter over the third, and a black object over the fourth. When used with a long exposure a two-stop filter factor must be added. The filters create the effect of a background in motion with six fringed colors: red, green, blue, yellow, magenta, and cyan.

MULTIPLE EXPOSURES

Multiple exposures can be used to superimpose disproportionate elements, to suggest motion, to create stroboscopic and zoom effects, to make creative ghost images, and to solve multiple lighting problems.

A ghostlike quality can be added to a still life by making two exposures of the same set. The first exposure should be one third of the total exposure required, and it should include all the props used in the composition. The items to be ghosted are then removed from the set, and the other two thirds of the exposure is made. The effect will be heightened if some of the ghosted images overlap other props in the composition.

One object can be repeated many times with multiple exposures. Large-format cameras are best for this technique. The exact position of the subject in each exposure should be premarked on the ground glass with a sharpened grease pencil. The subject, which should be on a black background, is placed in its main position and lighted with double cross-lighting. (Double cross-lighting is edge lighting from both sides of the set.) Expose the image normally and remove the film holder. Move the subject to the next position, preferably slightly overlapping the first image. Turn off the light that was illuminating the side adjacent to the first exposure. Shoot the second exposure, and repeat this procedure as many times as necessary. The camera can be refocused after each exposure, but remember that if you are radically changing magnification, you will have to alter your exposure to compensate.

The same technique can be used to make a subject diminish in size and gain density until it disappears by fully exposing the first exposure, and underexposing the second exposure by one stop, the third exposure by two stops, and the fourth exposure by three or four stops.

A foreground and/or background can be made to appear to "jump" by underexposing the whole set by one stop for the first exposure. Move the foreground and background secondary props a fraction of an inch before making a second exposure, which should also be one stop underexposed. A light, dark, or medium-tone background can be used with this technique. A dark background will render the elements as two distinct images; a medium-tone background will give ghostlike edges to the props; a light background will cause the edges of the props to fog, making them look narrower than they really are. Colored filters work well with this method.

A shaft of sunlight can be added to a picture by using multiple exposures. Expose the scene normally, and then prepare

To create the illusion of a large object inside a bottle, first shoot the bottle against a light background that blends to black behind it. Trace the shape of the bottle on the ground glass of the camera, or make a sketch of it. Prepare for a double exposure, and carefully position the second element against a black background that fits within the outline of the bottle.

This photograph of a Van de Graaff generator, distributor cap, and spark is a multiple exposure. The generator and distributor cap were placed on a backdrop of black velvet, normally lighted, and exposed. All the studio lights were then turned off and the generator was charged. The shutter, set for time exposure, was left open until the spark arced across the gap.

for the second exposure. Determine the direction of the lighting, and place a bare floodlamp or a small spot several inches behind a black cardboard with a narrow slit cut in it on the side from which the scene lighting is coming. This slitted illumination will throw a shaft of light across the scene. Drape the background with black velvet so it will not record again, and gently shake chalk dust from a blackboard eraser over the slit of light. You will have created a beautiful shaft of light.

Multiple lighting problems can also be solved with multiple-exposure techniques. A highly reflective or projected background may be influenced by a spill from the foreground lighting, totally spoiling the effect. When this happens, place a piece of black cardboard between the foreground subject and the background and shoot the foreground normally. Remove the black card, turn off all foreground lights, light the background, and shoot the second exposure.

Extreme depth of field can be achieved with multiple exposures by placing the subjects on a black background. Light and expose one element at a time, and refocus for each additional element.

Multiple exposures can also be done with a stroboscope—an electronic flash that can be adjusted to flash repeatedly at regular, predetermined intervals. The stroboscope was originally designed for scientific instrumentation and measurement. Inexpensive stroboscopes used in discotheques are available from theatrical supply stores. Although these strobes are not scientifically calibrated, they are suitable for general photographic purposes. Strobe motion shots work best with laterally moving subjects. Panning the camera while the strobe is flashing will result in multiple images. A low-powered tungsten lamp with a daylight conversion filter used in conjunction with the strobe will give lines of motion between the sharp exposures. When using two types of light, balance should be determined both with a strobe meter capable of cumulative readings and an ambient meter. Alternatively, take a test shot using an instant-print camera or a Polaroid back on a large-format camera.

ZOOMING

Zooming is the effect achieved by making multiple exposures of a subject with a zoom lens as the lens is moved through its focal range. Zooming can be done with either multiple shutter exposures or repetitive flashes. The subject should be placed in front of a black background to avoid multiple-exposure flare. To achieve the easiest zoom effect, first make a normal exposure of a fully lighted subject with the lens at its shortest focal length. Next, relight the subject using double-back cross-lighting so that the front of the subject is shaded. Make the second exposure, with the shutter set at time, while you move the lens through its entire zoom range. The image will appear as a soft outline shape of the subject and will diminish in size to a sharp, fully lighted version of the subject.

A repetitive zoom effect is created in much the same way. Fully light the subject, and make a normal exposure at the shortest focal length. Change the lighting to double-back cross-lighting, and make multiple exposures on the frame as you move the lens through its focal range. Then, using only cross-lighting with the shutter set on time, evenly zoom the lens back to its shortest focal length. The picture will have multiple, delineated images, with transitional light streaks that diminish to a fully lighted image of the subject.

With zooming you can make one subject appear to turn into another. For example, a perfume bottle can be zoomed and appear to become a girl's face. This procedure requires extreme care. First, cross-light the girl with tungsten light

A soft to sharp zoom is shown in this photograph of a Japanese doll. The doll was lit with two rear side lights (double cross-lighting) and a front light in the original exposure; the front light was turned off while the camera was zoomed.

corrected to daylight balance. Next, light the front of the girl's face with electronic flash that gives the same exposure as the tungsten light. Set the camera for a 1-second exposure, and adjust the lens to its shortest focal length. Release the shutter, which will trip the flash, and at the same time zoom the lens halfway through its focal range. Stop the zoom action when the shutter closes. Without moving the camera or lens, prepare for a double exposure. Position the perfume bottle so that it is the same size as the girl was at the completion of the first zoom. Open the shutter and continue the zoom, ending at the lens's longest focal length. The bottle should receive a little more exposure at this point. You then will have completed the effect.

Zoom effects can also be created with a normal lens. Mount the tripod on wheels set in a track, and make multiple exposures as the camera is moved away from the subject. A streak exposure can be added by opening the shutter and moving the camera back to its original position.

SUPERIMPOSITION

Superimposition of images can be done with beam splitters. Place the beam splitter (described in Chapter 9) at a 45-degree angle to the axis of the lens. When the composition is set, position the element to be superimposed so that its image will be reflected from the camera side of the beam splitter. By moving the element, it can be placed anywhere in the picture. The reflected subject (the element to be superimposed) will require more light than the subject immediately in front of the lens, as nonsilvered beam splitters pass as much light through as is reflected. Elements to be superimposed can be abstract shapes, recognizable shapes, miniature sets, or photographs.

A variation of this technique, known in the motion-picture industry as the Shufftan process, permits matching or mating of a subject with a photo or miniature set in front of the camera. The camera is set up, a mirror is interposed between it and the subject, the photograph or miniature set is positioned to the side of the camera, and the silver is then scraped from the back of the mirror until a perfect blending of the subject and reflection is obtained. The scraped line can be completely masked by positioning it to coincide with dark points on the two setups. The photograph or miniature set reflected in the mirror must be reversed. Although expensive, a front-surface mirror should be used, because regular rear-surface mirrors will often produce unwanted double-image reflections.

FRONT AND REAR PROJECTION

Front and rear projection are other ways to superimpose images.

The cost of a front projection system is prohibitive for the occasional user. This system incorporates a slide projector mounted at a 90-degree angle to the axis of the camera lens. The projector sends a background slide through a beam splitter onto a special screen that directs all of the light back to its source—in this case, the camera. The screen material is so efficient that only 1 footcandle of illumination on the screen is necessary to balance 200 footcandles of main light on the foreground subject.

Rear, or back, projection is a more practical solution for the nonprofessional photographer. A commercial rear-projection screen, a fine ground glass, or a piece of frosted plastic is set up close enough to the foreground subject to maintain depth of field, but far enough away to keep any extraneous foreground light from striking the screen. A slide projector is placed behind the screen on the same axis as the camera lens; the background slide is projected onto the screen. The foreground subject is lighted to match visually the luminance of the rear-screen

A beam-splitter was used to merge these two Thai dolls together. The blue doll was actually in front of the camera; the red doll was reflected onto the set by a 1/8-inch piece of window glass. The glass was positioned at a 45-degree angle between the blue doll and the camera. The red doll was to the right of the camera, halfway between the camera and the blue doll. A spotlight to the left reflects the image of the doll through the beam-splitter onto the blue doll.

Rear projection was used to create this rainbow shot. The spectrum was created by directing specular light through a prism, directing the resulting rainbow onto a white board, and photographing it on Kodachrome 64. To make the final shot, the bottles were set up on a mirror and lit with a spotlight to the left and card reflector to the right. A sheet of frosted plastic was placed at the rear of the set. The slide was projected onto the plastic from the rear and to the left to avoid a hot spot from the projector light and to leave a black area for type.

Capturing the carbon dioxide escaping from a carbonated-drink bottle was actually not that hard—all it took was timing. An assistant pried off the bottle cap and the photographer snapped the shot, using a strobe with a flash duration of 1/350 second.

This somewhat corny shot illustrating the hazards of cheating at cards summarizes the life of a still-life photographer. The bottle was exploded by having an assistant shoot a ball bearing through the bottle with a slingshot. Fourteen exposures were needed to get just the right shot, the set had to be cleaned up and re-made after each one. On the thirteenth exposure, the ball bearing went through the bottle without exploding it; on the fourteenth, the photographer forgot to pull the dark slide on the camera.

image. Exposure should be determined with a reflectance meter.

All rear-screen projections have hot spots, but they can be minimized by using a longer-focal-length lens on both the camera and the projector. The foreground subject can often be positioned to cover the hot spot. A hot spot can be totally removed by shifting the projector away from the camera axis, but the projections will then be brighter on the side adjacent to the projector. Rear projection is ideal for placing an exotic scene in the window of a set, for suggesting an outdoor scene, or for introducing a totally abstract background. Make sure that the edge of the screen does not show, unless that edge is something like a window. When simulating outdoor scenes, the foreground subject should be on a table, which supplies a horizon line.

Soft, sheer materials can be used as rear screens, particularly with abstract backgrounds such as a very close-up study of a flower petal or a person's eye.

All of these special effects have their place in still-life photography, but use them sparingly. Gimmickry can be overdone especially when it is employed for its own sake.

Appendix

COLOR TEMPERATURE OF VARYING LIGHT SOURCES AND THEIR MIRED VALUE

Light Source	Color Temperature in Degrees Kelvin	Mired Value
Sunlight—mean noon	5400	185
Blue sky—north light only	15000 – 27000	60 – 40
Open shade	10000 – 18000	100 – 56
Hazy skylight	7000 – 9000	143 – 111
Overcast sky	6500 – 7000	154 – 143
Hazy sunlight	5700 – 6000	172 – 167
Average daylight	5500 – 6000	182 – 167
Morning or afternoon sunlight	5000 – 5500	200 – 182
Direct sun at sunrise or sunset	3000 – 4500	330 – 220
Sunlight—sunrise or sunset	2000	500
One hour after sunrise—sunlight	3500	286
Early morning and late afternoon sunlight	4300	233
Average summer sunlight	5400	185
Direct mid-summer sunlight	5800	172
Summer skylight	9500 – 30000	105 – 33
Match flame	1700	588
Candle flame	1850	541
100–250-watt tungsten bulbs	2600 – 2900	305 – 345
3200-degree photo lamps	3200	313
Photofloods	3400	294
Blue-coated photofloods	4800	208

SUGGESTED FILTRATION FOR FLUORESCENT TUBES AND OTHER NON-CONTINUOUS LIGHT SOURCES

Light Source	Filters for Daylight Film	Type A Film
Cool White Fluorescent	30 M	60 R + 10 Y
Warm White	40 B	30 R
Warm White Deluxe	30 B + 30 C	10 Y
Cool White Deluxe	20 B + 10 C	20 R + 20 Y
White Fluorescent	20 B + 10 M	40 R
Daylight Fluorescent	30 R + 10 Y	30 Y
G.E. Lucalux	50 C + 10 B	30 M
Clear Mercury Vapor	Unfilterable, use supplementary lighting	
White Mercury Vapor	50 R + 10 M	30 G + 20 Y
Xenon	10 R + 10 Y	30 Y + 20 R

RECIPROCITY CORRECTION OF EXPOSURE
FOR SOME COMMON FILMS

The formulas listed below require a calculator capable of calculations in powers.

Kodachrome 64, 25 and Type A: Corrected Exposure = Indicated Exposure$^{1.51}$
Black-and-white roll films: Corrected Exposure = Indicated Exposure$^{1.48}$
Ektachrome Daylight: Corrected Exposure = Indicated Exposure$^{1.51}$
Ektachrome Type B: Corrected Exposure = Indicated Exposure$^{1.1}$

Most black-and-white films require a reduction of development of between 20% and 30% with extremely long exposures.

Reciprocity exposure indications do not include color changes, which may vary from emulsion to emulsion.

A simple calculation for Kodachrome, Ektachrome Daylight Type and black-and-white films is:
Corrected Exposure = Indicated Exposure Time × the square root of Indicated Exposure Time

LIGHT-BALANCING FILTERS:
TO CHANGE THE COLOR TEMPERATURE OF LIGHT

Filter	Filter Factor in Stops	Mired Value	Color
82	1/3	−10	Bluish
82A	1/3	−21	Bluish
82B	2/3	−32	Bluish
82C	2/3	−45	Bluish
81	1/3	+9	Yellowish
81A	1/3	+18	Yellowish
81B	1/3	+27	Yellowish
81C	1/3	+35	Yellowish
81D	2/3	+42	Yellowish
81EF	2/3	+52	Yellowish

COLOR CONVERSION FILTERS TO CONVERT DAYLIGHT FILM TO
TUNGSTEN BALANCE OR TUNGSTEN FILM TO DAYLIGHT BALANCE

80D	1/3	−56	Blue
80C	1	−81	Blue
80B	1 2/3	−112	Blue
80A	2	−131	Blue
85	2/3	+112	Orange
85B	2/3	+131	Orange

COLOR-COMPENSATING FILTERS AND THEIR FACTORS IN F-STOPS

Peak Density	Filter Factor					
	YELLOW	MAGENTA	CYAN	RED	GREEN	BLUE
.05	—	1/3	1/3	1/3	1/3	1/3
.10	1/3	1/3	1/3	1/3	1/3	1/3
.20	1/3	1/3	1/3	1/3	1/3	2/3
.30	1/3	2/3	2/3	2/3	2/3	2/3
.40	1/3	2/3	2/3	2/3	2/3	1
.50	2/3	2/3	1	1	1	1 1/3

Scale-Model Calibration

Model calibration is a bit long and involved but of great value to the still-life photographer. A number of years ago I was commissioned to create a set that approximated a spiral staircase in a lighthouse. A scale model of this in itself is rather difficult and in this case the problem was compounded, because the foreground element, a patterned floor, had to be reproduced in full scale and the model had to diminish in geometric progression so that the most distant point of the set appeared to be 48 feet from the camera. The set actually covered a space of 10 feet from the lens to the bottom of the set. A number of mathematical computations were required to accomplish this mighty chore. The basic formulas are:

Magnification = image size/object size

Total lens extension = (image size/object size × F.L.) + F.L.; or

Total lens extension = (mag. × F.L.) + F.L. or (M + 1) × F.L.

Object distance = lens extension × F.L./lens extension − F.L.; or

Object distance = (1/mag. × F.L.) + F.L.

Object size = distance × image size/F.L.

Image size = F.L. × object size/distance

Slope of angle of coverage = distance/coverage

Image size when focused for mag. = F.L. × (M + 1) × object size/distance

Object size when focused for mag. = distance × image size/F.L. × (M + 1)

First, determine the magnification of the foreground subject. The magnification in this case was .5 ×. The lens used had a focal length of 12"; the format was 8 × 10:

Extension = (M + 1) × F.L. = (.5 + 1) × 12 = 18"

The effective focal length is 18" for the calculation of lens coverage. Next, determine the angle of coverage of the lens. The foreground element at .5 × magnification is 36" from the lens:

Distance = (1/mag. × F.L.) + F.L. = (1/.5 × 12) + 12 = 36"

Assume that the foreground object is 12" long. A 12" object will reproduce as 6" at a distance of 36" when shot with a 12" lens.

Image = F.L. × (M + 1) × object/dist. = 12 × 1.5 × 12/36 = 6"

A 12" object will reproduce as .375" at a distance of 48' or 576".

Image = F.L. × (M + 1) × object/distance = 12 × 1.5 × 12/576 = .375".

The angle of coverage of the lens is calculated by multiplying the longest dimension of your camera back by the farthest distance and dividing this figure by the F.L. × (M + 1): 576 × 10/12 × 1.5 = 320"

Next, determine the slope: Slope = distance/coverage = 576/320 = 1.8

The geometric progression of distances is determined by the following formula:

Actual Distance	×	Slope factor	=	Distance between divisions	Total distance from lens
36"	×	1.0	=	36"	36"
72"	×	1.8	=	64"	64"
144"	×	.9	=	32"	96"
288"	×	.45	=	16"	112"
576"	×	.225	=	8"	120"

The slope figures diminish proportionately to the distance. Optically an object will be one-half the size at double the distance. The total set will be 10' or 120".

The size of the actual model elements is found by using this formula: Image = F.L. × (M + 1) × object/distance

Actual Distance	Correlated Image	Distance			12" object size in model will be
36"	6.0"	36"	36 ×	6/18	12"
72"	3.0"	64"	64 ×	3/18	10.6666"
144"	1.5"	96"	96 × 1.5/18		8"
288"	.75"	112"	112 ×	.75/18	4.6666"
576"	.375"	120"	120 ×	.375/18	2.5"

Further Reading

Adams, Ansel. *The Negative*. Boston: New York Graphic Society, 1948.

Adams, Ansel. *The Print*. Boston: New York Graphic Society, 1950.

Arnheim, Rudolph. *Art and Visual Perception*. Berkeley, Ca.: University of California Press, 1974.

Bullied, H.A.V. *Special Effects in Cinematography*. London: The Fountain Press, 1960.

Garrett, Lillian. *Visual Design*. New York: Van Nostrand Reinhold, 1967.

Gombrich, E.H. *Art and Illusion*. Princeton, N.J.: Princeton University Press, 1972.

Graves, Maitland. *The Art of Color and Design*. New York: McGraw-Hill Book Co., 1941.

Hofman, Armin. *Graphic Design Manual*. New York: D. Van Nostrand, 1946.

Itten, Johannes. *The Elements of Color*. New York: Van Nostrand Reinhold Company, 1970.

Munsell, A.H. *A Color Notation*. Baltimore, Md.: Macbeth, a division of Kollmorgen Corp., 1981.

Neblette, C.B. *Photography, Principles and Practice*. New York: D. Van Nostrand Co., 1942.

Pope-Hennessy, John. *The Portrait in the Renaissance*. New York: Pantheon, 1966.

Rand, Paul. *Thoughts on Design*. New York: D. Van Nostrand Co., 1971.

Sanders, Norman. *Photographic Tone Control*. Dobbs Ferry, N.Y.: Morgan and Morgan, 1977.

Wakefield, G.L. *Practical Sensitometry*. London: The Fountain Press, 1970.

White, Minor, Zakia, Richard, and Lorenz, Peter. *The New Zone System Manual*. Dobbs Ferry, N.Y.: Morgan and Morgan, 1976.

Glossary

Aberration. A fault in a lens causing a distorted image. Modern lenses contain few aberrations. The most common kinds of aberrations are spherical, chromatic, coma, and astigmatic.

Accelerator. A chemical found in developers, usually sodium carbonate or borax, used to speed up development.

Acetic acid. An acid used in stop baths and acid fixers. It is usually used in diluted form.

Acid fixer. A fixer containing an acid, generally acetic acid.

Acid hardening fixer. An acid fixer containing a hardening agent, usually alum.

Acutance. An objective measurement of image sharpness, based on how well an edge is recorded in the photograph. An image with high acutance would appear sharper and more detailed than the same image with low acutance.

Additive color. Color produced by light in the primary colors blue, green, and red, either singly or in combination. Combining all three primary colors produces white light. Additive color is the principle behind color television.

Agitation. The technique of ensuring even processing by moving the film or paper within the processing solution, or stirring the solution itself.

Alum. A chemical often used in fixers as a hardening agent.

Angle of incidence. The angle at which light strikes a surface.

Angle of reflectance. After light strikes a surface, the angle at which it is reflected.

Angle of view. The widest angle of light taken in by a lens. On any lens, the angle of view is widest when focused at infinity; long lenses have narrower angles of view than shorter lenses.

Anti-halation layer. A thin layer found in film, designed to prevent light striking the film base from reflecting back into the emulsion layers and causing halation.

Aperture. The part of a lens that admits light, the aperture is a circular, adjustable opening.

Archival processing. A method of processing black-and-white film and prints to ensure that they will not deteriorate over time.

ASA. American Standards Association. The sensitivity of a film to light, or its speed, is measured by the ASA standard.

Autowinder. A motorized unit attached to an SLR camera to automatically advance the film and cock the shutter.

Available light. The existing light on the subject, whatever the source may be. This term is often used to describe a low-light

Back lighting. Light directed toward the camera from behind the subject.

Barn doors. Flaps that attach to the rim of a photo light and can be adjusted to control the amount and direction of light.

Baseboard. The board on which an enlarger stands; any board used as a base for photographic paper.

Bas-relief. A photograph with a three-dimensional effect, created by sandwiching a negative and positive together slightly out of register and then printing the sandwich.

Beam splitter. A clear circle of glass used to simultaneously transmit and reflect a beam of light.

Bellows. A folding chamber, generally of light-tight cloth, between the lens and body of a camera, used to adjust the distance or angle between the film plane and the lens.

Bleach. A chemical bath that reacts with the black silver formed by the developer, either by dissolving it or converting it back to silver salts.

Blocked up. An overexposed or under-developed area of negative that prints as a light, undetailed area.

Bounce light. Light from an artificial source that is reflected onto the subject to give a diffused effect.

Bracketing. Making a series of exposures of the same subject, varying the exposure in increments around the estimated correct exposure.

Brightness. A subjective, comparative measurement of luminance.

Brightness range. The difference in brightness between the darkest and lightest areas of a scene or image.

Burning-in. The technique of giving additional exposure to selected parts of an image during printing.

Bromide paper. A type of black-and-white printing paper containing silver bromide in the emulsion and giving a blue-black image color.

Candela. The internationally recognized standard unit of measurement of luminous intensity.

CC filters. Color correcting filters, available in assorted colors and with densities ranging from .05 to .50.

Characteristic curve. A graph indicating the relationship between exposure and density for a photographic film.

Chroma. In the Munsell system of color classification, the saturation (purity) of a color.

Circle of confusion. A ray of light focused on the film plane registers on the film as a point. If the ray is not in focus, it registers as a tiny disk, or circle of confusion. If the circle of confusion is small enough, it will be indistinguishable from a point and the picture will be acceptably sharp.

Cold-tone developer. Paper developer that gives a blue-black color to the image on the photographic paper.

Color cast. An overall tint in an image, caused by light sources that do not match the sensitivity of the film, by reciprocity failure, or by poor storage or processing.

Color temperature. A system for measuring the color quality of a light source by comparing it to the color quality of light emitted when a theoretical black body is heated. Color temperature is measured in degrees Kelvin.

Coma. A lens aberration causing blurring at the edge of the image.

Combination printing. The technique of sandwiching two negatives together and then printing them.

Complementary colors. A pair of colors that, when mixed together by the additive process, produce white light.

Condenser. A simple, one-element lens found in enlargers and used to converge the light and focus it on the back of the enlarger lens.

Contact print. A print created by placing the negative(s) in direct contact with the printing paper. No enlarger lens is necessary.

Continuous tone. Reproducing or capable of reproducing a range of tones from pure black to pure white.

Contrast. The difference between tones in an image.

Contrast grade. A number indicating the contrast level produced by a particular photographic paper. The higher the grade on a scale of 0 to 5, the greater the contrast of the paper.

Cookie. A shading device made of a translucent material to give a mottled distribution of light.

Copper toning. Adding a warm, reddish-brown color to a print by using a copper-based toner. The long-term stability of a copper-toned print is not good.

Cropping. Selecting a portion of an image for reproduction in order to modify the composition.

Cyan. A blue-green color, the complement of red; one of the three subtractive primary colors.

D log E curve. A characteristic curve for a photographic emulsion, indicating the relationship of the density of the emulsion to the log of the exposure.

Density. The ability of a developed silver deposit on a photographic emulsion to block light. The greater the density of an area, the greater its ability to block light and the darker its appearance.

Densitometer. An instrument for measuring density.

Density range. The difference between the minimum density of a print or film and its maximum density.

Depth of focus. The distance the film plane can be moved while still maintaining acceptable focus, without refocusing the lens.

Developer. A chemical solution that changes the latent image on exposed film or paper into a visible image.

Diaphragm. *See* Aperture

Diffraction. The scattering of light waves as they strike the edge of an opaque material.

Diffused image. An image that appears to be soft and has indistinct edges, generally created by shooting or printing with a diffusing device.

Diffused light. Light that produces soft outlines and relatively light and indistinct shadows.

Diffuser. A translucent material that scatters light passed through it.

Diopter. A measurement of the refractive quality of a lens. Usually used in connection with supplementary close-up lenses to indicate their degree of magnification.

Dodging. The technique of giving less exposure to selected parts of an image during printing.

Double exposure. The exposure of two different images on a single piece of film.

Drying marks. Marks occasionally left on processed film after it dries. They can be avoided by use of a wetting agent and removed by careful rewashing.

Easel. A frame for holding printing paper flat during exposure.

Electronic flash. A short, bright artificial light produced by passing electricity across two electrodes in a gas-filled glass chamber.

Emulsion. A light-sensitive layer of silver halide salts suspended in gelatin and coated onto a paper or film base.

Enlargement. A print made from a smaller negative.

Enlarger. A device used to project and enlarge an image of a negative onto photographic paper or film.

Exposure. The amount of light allowed to reach a photographic emulsion.

Exposure factor. *See* Filter factor

Exposure latitude. The maximum change in exposure from the ideal exposure that will still give acceptable results.

Exposure meter. An instrument designed to indicate the amount of light either falling on or reflected by the subject.

Extension rings or tubes. Rings or short tubes that fit between the body and lens of a camera, designed to increase the focal length of the lens for close-up work.

Farmer's reducer. A solution, consisting of hypo (sodium thiosulphite) and potassium ferricyanide, used to lighten all or part of a black-and-white negative or print.

Fill flash. A flash unit used to supplement the existing light, particularly outdoors.

Fill light. A supplemental light used to reduce shadows and contrast caused by a main light.

Filter factor. The increase in exposure needed when filters are placed in front of the lens.

Fixer. A chemical solution that dissolves the remaining silver halides in an image, making it permanent.

Flag. A square or rectangular reflector attached to a stand.

Flare. Stray light, not part of the image, that reaches the film in the camera because of scattering and reflection within the lens.

Flatness. Lack of contrast in an image, caused by overly diffuse light, underdevelopment or underexposure, or flare.

Floodlight. A tungsten light and reflector.

Focal length. The distance between the center of a lens and the film when the lens is focused at infinity.

Focal plane. The plane behind the lens where the sharpest image from the lens falls; the plane of the film.

Fog. Density on a photographic emulsion

caused by accidental exposure to light or by processing chemicals and not part of the photographic image.

Fogging. In the camera, deliberately exposing the film to unfocused light, either before or after photographing a subject, in order to reduce contrast. In the darkroom, a usually accidental development of the film or paper because of something other than exposure (e.g., chemical contaminants).

Fresnel lens. A thin condenser lens with a number of concentric ridges on it, used to distribute brightness evenly in spotlights and viewing screens.

Fresnel screen. A viewing screen incorporating a Fresnel lens.

Front element. In a lens, the piece of glass furthest from the film plane.

Gamma. A number, derived from the steepness of the straight-line portion of the characteristic curve of an emulsion, indicating the degree of development the emulsion has received. The more developement the film has received, the higher the value of gamma and the greater the contrast.

Gelatin. The substance in an emulsion in which the light-sensitive particles of silver halide are suspended.

Gelatin filters. Colored filters that provide strong overall color effects.

Glossy paper. An extremely smooth type of photographic paper giving a great range of tones from pure white to pure black.

Gobo. A flat, black flag, usually a small circle or square, used to block or direct the light from a photo lamp.

Gradation. The range of tones, from white to black, found in a print or negative.

Grade. The measurement of the degree of contrast of a photographic paper, usually on a scale of 0 to 4.

Gray scale. A series of patches, joined together, of shades of gray ranging from white to balck in equal increments.

Ground glass. A sheet of glass ground to a translucent finish, used for focusing.

Guide number. A number on an electronic flash unit indicating its power.

H & D curve. A performance curve for a photographic emulsion, named for Hurter and Driffield, its developers and pioneers in the field of sensitometry.

Halation. The undesirable effect created when light passes through an emulsion, strikes the backing, and is reflected back through the emulsion, reexposing it.

Hardener. A chemical, usually incorporated into the fixer, that causes an emulsion to harden while drying, making it less susceptible to damage.

High-contrast paper. Photographic printing paper with a great deal of contrast, generally about grade 4.

Highlight mask. An intermediate positive or negative created to retain the highlights when duplicating.

Highlights. The areas of a photograph that are only barely darker than pure white.

Hot spots. A part of a scene or photograph that is relatively over-lit, often caused by poor placement of lights.

Hue. The name of a color.

Hyperfocal distance. When a lens is focused at infinity, the minimum distance at which it will record a subject sharply.

Hypo. Another name for sodium thiosulfate or fixer.

Hypo clearing bath (eliminator). A chemical solution used to shorten the washing time needed after fixing.

Illumination. The amount of light falling on a subject.

Incident light meter. A light meter used to measure the light falling on the subject.

Infrared film. Film sensitive to the infrared end of the spectrum, beyond the light visible to the human eye.

Intensifier. A chemical used to add density or contrast to a negative that is too thin for satisfactory printing.

Inverse square law. The principle that the amount of light falling on a subject varies in relation to the square of the distance between the light source and the subject.

Iron-blue toning. Adding a brilliant blue color to a print by using an iron-based toner.

Kelvin. The unit used to measure color temperature; the Celsius temperature plus 273.

Keystoning. A distortion of perspective that makes parallel lines appear to converge as they recede in the photograph.

Latitude. The amount of over- or underexposure a photographic emulsion can receive and still produce acceptable results.

Light cone. A cone made of a translucent material and used to diffuse evenly the light falling on the subject.

Light tent. A tent made of a translucent material, designed to be placed over the subject to provide shadowless, diffuse light.

Lighting ratio. A comparison of the amount of light falling on one side of the subject with the amount falling on the other side.

Line print. An outline effect created by sandwiching a positive and negative Kodalith of the same image and then making the print by passing light through the sandwich at a 45-degree angle.

Lith developer. A developer designed specifically for lith films.

Lith film. A very high-contrast film emulsion used for a number of darkroom special effects; Kodalith is the best-known brand.

Lumen. The amount of light reaching one square foot of a surface one foot from a light emitting one candela of intensity. The standard unit of measurement of luminance.

Luminance. The brightness of a light.

Mackie lines. In solarization or the Sabattier effect, the clear, undeveloped lines created where the positive and negative parts of the image meet.

Macro lens. A lens capable of very close focusing without supplementary close-up lenses, and usually capable of producing a 1:1 image on the film.

Macro photography. Photography that produces images generally ranging from one-half to ten times life-size. Images larger than ten times life-size are usually created by photography through a microscope.

Magenta. One of the three subtractive primary colors; the others are cyan and yellow.

Mask. A device used to modify or hide part of an image during printing.

Matte. A descriptive term for any surface that is relatively nonreflective.

Mid-range. Those tones in a scene that fall midway between the darkest and lightest tones.

Mired. A measurement of color temperature used to find the difference between light sources and calculate the effect of color filters.

Modeling light. A small spotlight that can be precisely directed.

Montage. A composite picture made by combining elements from different photographs together.

Motor drive. A device used to advance film automatically through the camera, often at greater speeds and with more versatility than an autowinder.

Munsell system. A systematic method of color classification based on the three dimensions of color: hue (the name of the color), value (its lightness), and chroma (its saturation).

Neutral density filter. A filter, available in varying intensities, that reduces the amount of light reaching the film without affecting its color.

Negative carrier. A holder used to position the negative correctly between the enlarger light and the enlarger lens.

One-shot solution. Any processing solution designed to be used once and then discarded.

Opaquing. 1. The technique of covering parts of a negative with an opaquing solution to block out the image in that area. 2. To fill in pinholes in Kodalith negatives or positives with an opaquing solution.

Orthochromatic. An emulsion, either paper or film, that is sensitive to green, blue, and ultraviolet light and can be handled under a dark red safelight.

Overdevelopment. Development for longer than the recommended time.

Overexposure. Exposure for longer than the recommended time.

Panchromatic. Sensitive to all the colors of the visible spectrum.

Panning. Moving the camera to follow a moving subject and keep it continuously in the viewfinder.

Parallax. Of particular importance when using non-SLR cameras, parallax is the apparent movement of objects relative to each other when seen from different places.

Photoflood. A tungsten light with a color temperature of 3400° K.

Polarized light. Light that vibrates in only one plane rather than many.

Polarizing screen. A rotating filter attachment that allows light vibrating in only one plane to pass through the lens.

Posterization. A high-contrast printing procedure producing a print with only two or three (sometimes more) tones.

Primary colors. Any three colors that can be combined to make any other color. In additive color, the primary colors are red, green, and blue; in subtractive color, the primary colors are yellow, magenta, and cyan.

Printing frame. A frame used to hold the negative and paper together when exposing a contact print.

Pull processing. Intentional under-development of a film or paper, usually because it has been overexposed.

Push processing. Intentional over-development of a film or paper, usually because it has been underexposed.

Quartz-halogen lamp. A tungsten-balanced photo light that burns brightly and evenly with consistent color temperature over a long period.

Reciprocity failure. During very long or very short exposures, the law of reciprocity no longer holds and film shows a loss of sensitivity, resulting in underexposure, and color changes in the case of color film.

Reciprocity law. The amount of exposure a film receives is the product of the intensity of the light (aperture) times the exposure time (shutter speed). A change in one is compensated for by a change in the other.

Reducer. A chemical solution used to reduce the density of a negative or print.

Reflected-light reading. A light reading taken by pointing the meter at the subject and measuring the light reflected from it.

Reflector. Any surface used to direct light onto or near the subject.

Replenisher. A solution added to a larger amount of the same solution to maintain its strength as it is depleted by use.

Resin-coated (RC) paper. Photographic printing paper with a plastic backing. RC paper dries quickly without curling.

Reticulation. A crazed pattern of cracks in the photographic emulsion, caused by a sudden change of temperature during processing.

Reversing rings. Adapters enabling the camera lens to be reversed and mounted for close-up work.

Rising front or standard. On a view camera, a lens panel that can be moved up or down.

Sabattier effect. The appearance of areas of both a positive and negative image on a film or paper, caused by brief exposure to light during development.

Safelight. A colored light that does not affect the photographic material in use. E.g., a dark red light used when processing orthochromatic film.

Saturation. The purity of a color; the more white light the color contains, the less saturated it is.

Scrim. A translucent material used to diffuse light shining through it.

Selenium toning. Adding a rich brown tone to a print by using a toner containing selenium.

Sensitometry. The exact measurement of the sensitivity of film and paper.

Sepia toning. Adding a brown or sepia color to a print by using a sulphide-based toner. Sepia toning adds interest and permanence to a print.

Silver halides. A general name for a group of light-sensitive chemicals used in photographic emulsions.

Skylight filter. A filter used to absorb excess ultraviolet radiation.

Snoot. A conical attachment for a photo light used to concentrate the light into a small, circular area.

Soft box. A light with built-in reflectors, giving diffuse light with soft shadows.

Soft-focus lens. A lens designed to give an image that is less than sharp and is slightly diffused.

Solarization. The creation of a combination

of a partially positive and negative image when a negative is greatly overexposed.

Split-focus lens. A lens attachment that is clear glass on one half and a plus-diopter close-up lens on the other, allowing a close foreground and a distant background to both be in focus.

Spotlight. A light source that gives a concentrated beam of light producing sharp shadows.

Spot meter. A hand-held exposure meter with a very narrow angle of view, used for measuring reflected light at a specific point.

Stock solution. Any processing solution that can be premixed and stored for later use in lesser amounts.

Stop bath. A chemical solution used to end the action of a developer.

Strobe light. An electronic flash unit.

Strobe meter. A flash exposure meter.

Sweep table. A table with a surface of translucent plastic that can be lit from underneath.

Swings. Horizontal movements on the front and rear standards of a view camera.

Target. A small, circular gobo.

Test strip. A series of different exposures on a single piece of paper or film, used to find the optimal exposure.

Tilts. Vertical movements of the front and rear standards of a view camera.

Tonal deletion. The elimination of shades of gray from a print, producing a high-contrast print using only black and white.

Tonal range. The gradations of gray between the darkest and lightest areas of a print or scene.

Toner. A chemical that adds color to or changes the color of a black-and-white print or negative.

Tone separation. *See* Posterization

Tungsten light. A lightbulb containing a tungsten filament and giving light with a color temperature of about 3200° K.

Ultraviolet filter. *See* Skylight filter

Ultraviolet radiation. Invisible energy just below the short-wavelength end of the visible spectrum, and present in many light sources.

Variable-contrast paper. Black-and-white printing paper that gives a range of contrast grades, depending on the filtration used in enlarging.

View camera. A large-format camera with movable front and rear standards joined by a bellows.

Vignetting. Darkening in the corners of an image, caused by the instrusion of the lens hood or filter into the subject area.

Warm-tone developer. Paper developer that gives a brown-black color to the image on the photographic paper.

Wetting agent. A chemical added to the last processing wash to ensure even drying.

Yellow. One the primary additive colors.

Zone System. A method for converting light measurement into exposure settings by analyzing the tonal range of the subject and dividing it into numbered zones.

Index

fabrics, 111–112
glassware, 107–109
in macro photography, 129
metallic objects, 109–111
miniature sets, 129–135
multiple-exposure techniques and, 152
shadowless, 118
texture, 111
wood objects, 112–114
Lighting ratio
determining, with reflectance meter, 47
use in outdoor photography, 93–99
Lights, balancing, 115
Luminance, 31, 47, 68
Luminance range, 43, 47–51
in outdoor photography, 93

m

Macro photography, 125–130
Magnification
in macro photography, 125–129
for miniature sets, 129–130
Midrange exposure, finding, 47
Miniature sets, 129–134
Mini-spots, 26–27
Mired shift, 101–103
Mired valuation, 102
Mirrors, 98
Modeling light, calibrating, 27
Monochromatic harmony, 70
Mood, in design, 17–19, 80, 121
Motion, 147–152
Multiple exposures, 152–155
Multiple lighting, 122–123

o

Optics and design, 66
Outdoor photography, 93–105

p

Paper, photographic, 48–50
Perspective, with view cameras, 137–139
Practical lamps, 117–118
Pre/post fogging, 50–51
Props, in design, 17–19, 80

r

Reciprocity failure, 53
Reflectance, in broad-source lighting, 37
Reflectors, 37, 93–98
as diffusing equipment, 28
in lighting metallic objects, 110
in local control of light, 118

reducing outdoor contrast, 93–97
Reversing rings, 126–128
Roscoe gels, 105, 115
Rotating shutter, 147–150

s

Scrim, 93, 98, 118
Short-focus lenses, 128
Simultaneous contrast, 77
Soft box, 28, 37, 107, 118
Soft-focus lens, homemade, 29
Space in design, 60
Special effects, 115–116, 147–161
Split-diopter lenses, 128–129
Spot meters, 23, 47
Spotlights, 26
Strobe meter, 23–24, 47
Stroboscope, 155
Studio strobe, 27
Sun, photographing, 105
Superimposition, 157
Sweep table, 29, 118

t

Tents, 29, 111
Texture, 111
Through-the-lens meter, 47, 129
Time of day, in outdoor photography, 93
Tone control, 43
Tripod, 24–25, 126
Tungsten lights, 26–27
balancing, 115, 155
2¼-inch camera, 21–22

u

Umbrellas, 28

v

Value plans, 68
View cameras, 137–145
diffusion with, 143
focus control, 139–143
formats, 22
image size and position, 137
perspective and distortion control, 137–138
swings and tilts, 25, 137, 143
Vignetting, 143

w

Wide-angle lens, in design, 66

z

Zone System, 48–51
Zooming, 155–157